RAINBOWS OF LIFE

The Promise of Kirlian Photography

RAINBOWS OF LIFE

MIKOL DAVIS

EARLE LANE

HARPER COLOPHON BOOKS
Harper & Row, Publishers
New York, Hagerstown, San Francisco, London

RAINBOWS OF LIFE: The Promise of Kirlian Photography. Copyright © 1978 by Mikol Davis. All rights reserved. Printed in the United States of America. No part of this book may be used or reproduced in any manner whatsoever without written permission except in the case of brief quotations embodied in critical articles and reviews. For information address Harper & Row, Publishers, Inc., 10 East 53d Street, New York, N.Y. 10022. Published simultaneously in Canada by Fitzhenry & Whiteside Limited, Toronto.

FIRST HARPER COLOPHON edition published 1978

Designed by Stephanie Krasnow

ISBN: 0-06-090624-3

78 79 80 81 82 10 9 8 7 6 5 4 3 2 1

Love, work and knowledge are the wellsprings of our life, they must also govern it.

—*Wilhelm Reich*

Contents

Color plates follow pages 32 and 64.

Acknowledgments

The authors would like to thank the following people for their help in research and publication of *Rainbows of Life:* Lawrence Amos, Peter Beren, Robert S. Boni, Susan Boulet, Tom Carpenter, H. S. Dakin, Michele Davis, the Heuristic Institute, James L. Hickman, John Hubacher, Toni Huntly, Stanley Krippner, Roz Lewis, W. Edward Mann Mirage, Thelma Moss, Richard Peterson, Gary Smith, and Matthew Wood.

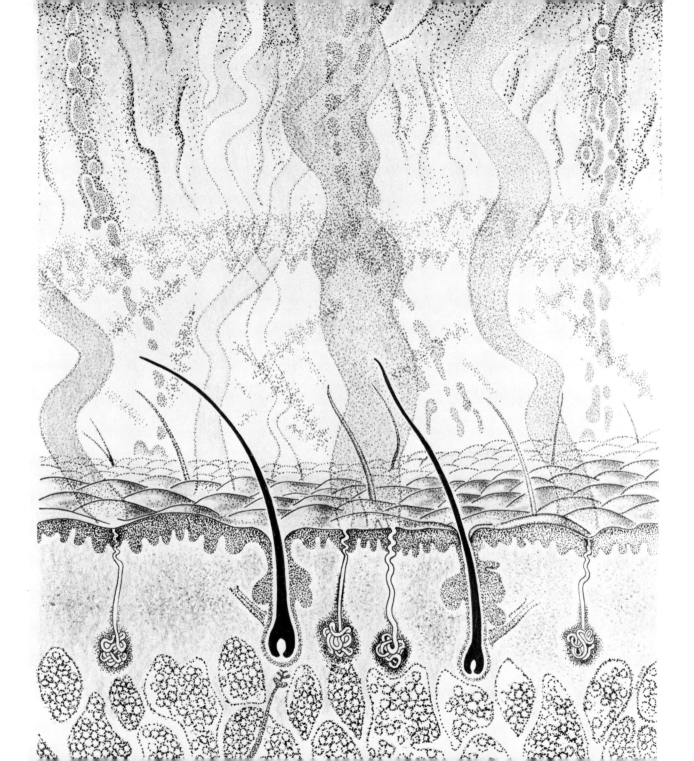

Introduction

You are about to embark on a journey into the etheric land of life energy. It's like a rainbow —it comes in colors everywhere. Rainbows of life, promising a new life vision.

Imagine these rainbows of life delicately flowing from the surface of your body. Your skin is *not* what separates you from the rest of the universe; it's what *connects* you to it. At the tiniest microscopic level in and about the surface of the skin, we can see bubbles of air, spheres of life, gases like oxygen and nitrogen. Bubbles of gas trapped by the body's electromagnetic fields. Trapped by the fields of life.

These gas spheres appear in different colors. To capture and photograph these colorful but elusive life bubbles is our destination.

As we proceed, a colorful mist takes form in our minds. As we charge the air of this microlandscape with a high-energy field, everything starts to glow. It's alive with color, luminous with meaning.

We see the acupuncture points like bright fountains. We see layer after layer of color: the northern lights in miniature. Trapped by the body's energy fields. Set aglow by our Kirlian apparatus, our plasmic body dances in these subtle environments. Pulsating charge/discharge/charge—the rhythm of life. The colors, the patterns, the textures are doing a dance of light, a dance of life: rainbows of life.

A piece of film emulsion: documentary evidence that captures—if only for a moment—this radiant landscape.

This is Kirlian photography.

Preface

StanLEY Krippner, Ph.D.
Humanistic Psychology Institute,
San Francisco, California

The technique of corona discharge photography, used chiefly to detect flaws in metal used in engineering, has been known in the West for many years. Nikola Tesla produced corona discharges in his experiments with electricity. In 1917, Dr. F. F. Strong of Tufts University Medical School used voltage from a Tesla coil to photograph his hand by placing it directly on a piece of film. Other corona discharge photographs had been produced by Yakov Narkevich-Todko and exhibited at a meeting of the Russian Technical Society in 1898. However, no systematic work with living organisms was carried out until Semyon Davidovitch Kirlian, a Soviet electrician, looked at the types of fields that corona discharge photography could produce around leaves, insects, animals, and human beings. His first scientific report, coauthored by his wife, Valentina Kirlian, appeared in the Russian *Journal of Scientific and Applied Photography* in 1961. In 1974, the Soviet government awarded Kirlian the title of Honored Inventor.

The device typically used in corona discharge photography consists of a flat metal plate with film positioned on its top. An object is placed on the film, and high-voltage electricity, at very low amperage, is pulsed through the metal plate. The electricity passes through the film and exposes it, producing an outline of the object on the plate as well as a surrounding corona. If the film is color sensitive, the corona discharge appears to contain a variety of colors.

Kirlian's work intrigued Thelma Moss of UCLA's Neuropsychiatric Institute, and in the early 1970s she began to produce fascinating photographs taken when subjects were experiencing altered states of consciousness. Emotional shifts and changes in health also produced different colors and flare patterns on what soon came to be known as Kirlian photographs.

Technical investigation identified a number of the interacting factors that produced the spectacular differences from one Kirlian photograph to another: condition of the electrode used, of the insulating materials, of the film and its manner of development, electrical characteristics of the high-voltage source, exposure time, surface conditions of the object photographed (for example, heat, weight, and pressure), grounding conditions, and environmental

conditions (such as air currents, ion content in a room, and even lunar pull and sunspots).

When a living organism is photographed, several other factors assume importance. They include sweat or water vapor, hydration or dehydration, roughness or smoothness of the surface photographed, degree of lipid concentration, degree of deposited impurities, and the total area of the surface on which the corona discharge is taking place. Finally, the experimenters themselves represent an important variable; their expectations and expertise may influence the results profoundly.

With all of these factors to keep in mind, is there any possibility that Kirlian photography can achieve the standardization needed for practical use? An optimistic note has been sounded by Yoshiaki Omura, chairperson of the Standards Committee of the International Kirlian Research Association. Writing in a 1976 issue of the *International Journal of Acupuncture and Electro-Therapeutic Research,* Dr. Omura said that "if most of the major parameters influencing Kirlian photography are measured or controlled, there is a fairly good possibility that Kirlian photography can be used for evaluating the various conditions of the human body or animal including emotional condition and certain early symptoms associated with certain diseases."

It is this promise of Kirlian photography that Mikol S. Davis and Earle Lane discuss in their remarkable book, *Rainbows of Life.* Davis and Lane trace the notion of life energies and the divergent points of view in regard to Kirlian photography. They also describe some of the more innovative research projects of the past few years. There are Moss's green-thumb and brown-thumb effects and, of course, the ubiquitous phantom-leaf effect reported from several laboratories. Some of the unique studies of Davis and Lane are discussed, including one of tobacco smokers. In this case, nonsmokers' coronas revealed a symmetrical corona, while smokers' coronas contained a large red blotch. Davis and Lane suspect that this blotch is due to peripheral vasoconstriction of the blood capillaries—a well-known effect of nicotine.

This explanation is more straightforward than some observers would prefer. But those who indulge in esoteric conjectures about Kirlian photography are discouraging serious researchers from investigating this phenomenon. For example, the October 1976 issue of *Science* contained an article, "Image Modulation in Corona Discharge Photography," that concluded that moisture is a principal determinant of the form and color of Kirlian photographs of human subjects. Despite this sensible interpretation of the data, a few scientists objected to the article's inclusion in *Science* because of the occult connotations some people have given to Kirlian photography.

When many acupuncture points were found to have unique electrical characteristics, a number of physicians breathed a sigh of relief because acupuncture could now be "explained" in a more conventional way, and put to practical use. The demystification of Kirlian photography can lead only to its wider investigation and application. We must always remain open to changing our models of the universe—and perhaps the phantom-leaf effect, if genuine, will

someday necessitate such a change. But in the meantime, we need to consider the ways in which Kirlian photography can solve some of the current problems in agriculture, biology, medicine, metallurgy, psychiatry, and psychology. To be useful in these fields, an interface is needed; Kirlian photography must make sense in terms that can be explained, controlled, and applied. Only then can the rainbows of life live up to their promise.

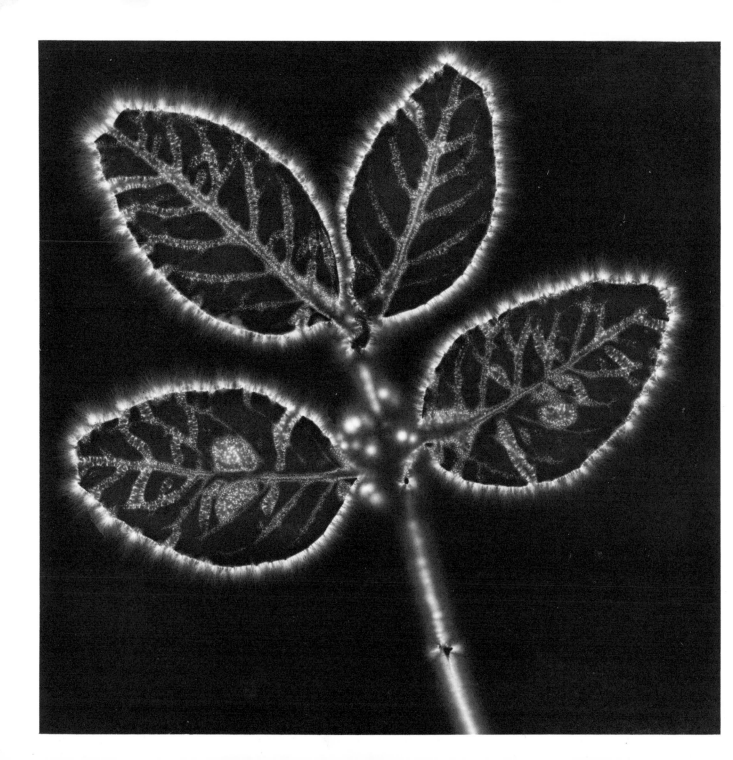

1

The Human Aura

"I am certain that a photographic picture of the size, shape and condition of the Human Aura is not only possible but will shortly be made, thus enabling the aura to become a still greater assistance in medical diagnosis."

—Dr. Walter J. Kilner, 1911
(1847–1920)

UNIVERSAL NOTIONS OF LIFE ENERGY

Throughout history, many civilizations have recorded occurrences when certain people, usually called "sensitives" or "psychics," have seen colorful, subtle rays emanating from the human body. This semi-invisible energy or fluid, which interpenetrates both the organism's internal environment and the external universe, has been called the "human aura."

The actual perception of this energy has been vividly described by Don Juan, the Yaqui Indian shaman celebrated in the works of Carlos Castaneda: "Tentacles come out of a man's body which are apparent to any sorcerer who *sees*. Sorcerers act toward people in accordance to the way they *see* their tentacles. Weak persons have very short, almost invisible fibers; strong persons have bright, long ones. . . . You can tell from the fibers if a person is healthy, or if he is sick, or if he is mean, or kind or treacherous."[1] These fibers of light, fine, delicate threads circling the body appear as luminous bristles, bursting out in all directions, connecting all beings to their surroundings.

While he does not refer to this energy as an "aura," it is obvious that Don Juan is describing the same wonder that now bears this label. And while specific terms for it may change, historical descriptions of it reflect an amazing consistency over the centuries. Often mystics and artists have depicted this elusive energy field as surrounding the body with a misty glow or luminous cloud—frequently given religious connotations by its interpreters. According to

17

tradition, for example, when Moses returned from Mount Sinai, his face shone so brightly that people were unable to look at him. And pictures of Jesus, Buddha, Krishna, and other religious figures often show a halo.

In ancient caves and on the walls of ruins in India, Egypt, Peru, and the Yucatán, pictorial testimony to the human aura appears with awesome regularity. However and wherever it is depicted, the human aura is a historical and anthropological constant.

For instance, according to Hindu tradition, it is a manifestation of a universal energy called prana. Prana comprises the Sanskrit *pra* (''forth'') and *an* (''to breathe, move, live''). Thus, prana may be translated as ''life energy.'' Yogic philosophy maintains that prana radiates as an aura around the physical body indicating the state of health. Furthermore, the aura indicates a person's physical power and magnetism. But that is not all. According to tradition, both power and magnetism may be imparted to others; that is, energy travels from one auric field to another.

Forms of energy common to everyday experience are all aspects of prana. ''Heat, light, electricity, are . . . manifestations of Prana. . . . Whatever moves, works or has life is but an expression or manifestation of Prana. . . . Prana is the link between the astral (or auric) and the physical body.''[2] The universal energy permeating the known universe, prana is seen as a link to another dimension of existence.

Illustration of prana

It flows through the universe in currents running through the four directions: north, south, east, and west. Similar currents exist in human bodies. Prana, which maintains life, is circulated by the process of inhalation and exhalation.

When India was a British colony, a group of medical doctors and researchers made an extensive study of prana. These early twentieth-century researchers translated the Hindu ideas into the language of science. They described prana as being present in every cell: "Free Prana travels over the sheaths of the nerves with great rapidity; Prana is thrown off from all extremities, all orifices and the pores of the skin. In a healthy body the Pranic flow from the body constitutes a fine spray of hope all around it."[3]

The research group went on to differentiate forms of prana: "There is also a form of *static* vitality closely associated with the structure of each cell and organ. The interplay of the quick-moving Prana, drawn in from the air, with the static Prana, anchored in the cells, constitutes the organism known as the vital body."[4]

The vital body, as the researchers defined it, extended from one-quarter of an inch to one inch outside the physical skin surface. Appearing as a rapidly moving grayish band, the vital body or aura radiated from the surface of the physical body.

OTHER CONCEPTS

The concept of a universal life energy like that of prana was also evident in other ancient cultures. The Egyptians called this energy ka; the Tibetans evolved a concept of light-energy-body; the ancient Hebrews spoke of ruah, or "breath of life."

Ch'i, a life-energy concept evolved in ancient China, persists to this day:

In Chinese medical philosophy, Ch'i is in a flow of blood and lymph and nervous impulses . . . which follows well-defined pathways called meridians. According to the Chinese explanation, whenever the flow of this energy along the meridians is either obstructed or weakened, the likelihood for sickness is increased. . . . It is proposed that we all exist suspended in a sea of energy which permeates between and through our body cells.[5]

Some authorities maintain that the concept of *ch'i* goes beyond a presence in living organisms; they have described it as "energy in a state of change; even in a rock there is a slow transformation of substance and energy."[6]

Ancient Polynesian culture evolved a life-energy concept, called mana, that closely paralleled that of prana and *ch'i*. In Hawaii, indigenous healers still use this concept: "Mana . . . is the life force and with it life is strong, while without it, it fades."[7]

One extensive study of *huna,* the secret tradition of Hawaiian shamans and medicine men

(who were known as kahunas) noted that kahunas were trained in utilizing and transmitting mana. According to the study, "A basic concept of the Kahunas was that the low self (the subconscious mind) takes this low-voltage force and steps up its voltage for its use in will. . . . The high self (the superconscious mind) can take the force and step it up to the highest voltage, whereupon it can emanate and perform healing miracles."[8]

Evidence of the human aura and its relationship to a universal life energy abounds in studies of widely disparate peoples and cultures. Frequently these concepts are closely related to ideas of natural healing forces. Spiritual healers, medicine men, and tribal shamans claimed to be able to use the energy field to heal their people.

Even Hippocrates made reference to the *enomron* (invisible emanations). He "wondered if a part of the natural healing force is a healing energy found in all organisms and in the air they breathe."[9] From the time of Hippocrates (fourth century B.C.) onward, the same concepts have persisted, in different forms, throughout Western culture.

Today, contemporary science stands poised, ready to examine traditional ideas of the human aura and life energy. The translation of these ideas into scientific theory is altering our basic conceptions of reality, and theories of life energy run as a constant thread through the history of science. Yet in order to comprehend contemporary theories of life energy, it is first necessary to look into concepts that have arisen in the West.

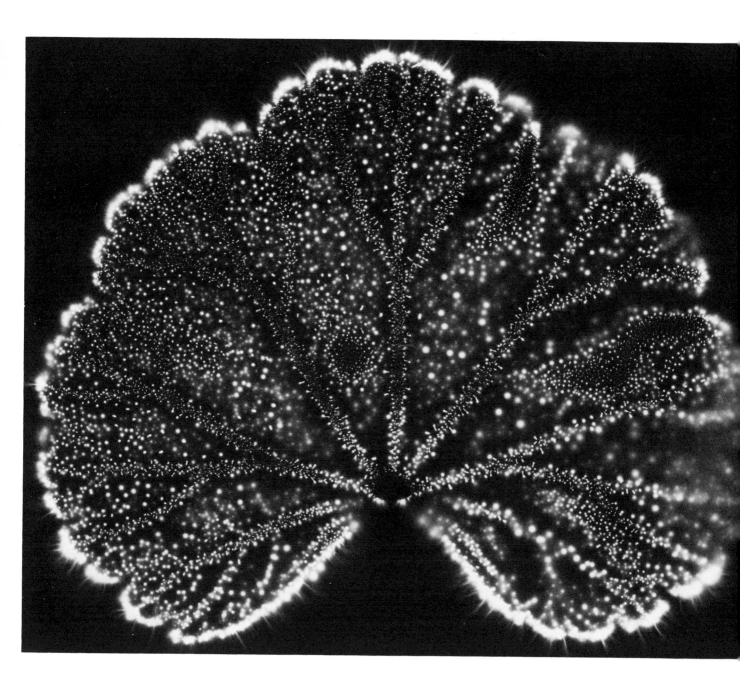

2

The Forgotten History of Life Energy

The moment when physics touches on the "untrodden, untreadable regions" and . . . when psychology too touches on an impenetrable darkness—then the intermediate realm of subtle bodies comes to live again, and the physical and the psychic are once more blended in an indissoluble unity.

—Carl Gustav Jung

FROM ALCHEMY TO THE ORGONE

The search for an underlying unity to explain the phenomenon of the life-force—both in individuals and in species at large—recurs throughout our recent history. Generally, these concepts were not well regarded by their contemporary scientific establishments; indeed, the best of these concepts often enjoyed only a brief vogue and vanished, only to reappear in another guise.

Yet the theories, regardless of the century or country in which they were spawned, show a remarkable similarity. Even the forgotten Western life-energy theories are in many ways similar to Eastern or traditional concepts, like the Yogic prana. It is almost as if humanity possessed an intuition about a universal energy, an intuitive perception that found expression in whatever ideas, scientific or otherwise, were current in a particular culture at a particular time.

Actually, the main thrust of Western culture has been antithetical to the life-energy philosophy. Over the centuries, the idea that matter had no inherent vitality, or "spirit," became more and more entrenched. It is only recently, with the advent of new ideas in physics, that the scientific establishment has begun to take a new look at the old and persistent ideas of an inherent force imbedded within matter.

The journey through the forgotten history of life energy in the West begins, appropriately, with an alchemist. Though history scoffs at alchemy and considers that its main contribution was as the primitive forerunner of chemistry, the alchemist was equally at home in the world of the philosopher and the world of the physical scientist. Unlike later scientists, the alchemist had no limiting concepts of specialization or duality to prevent him from theorizing.

The Archaeus, Liquor Vitae, and Munia

A Swiss army surgeon, university lecturer, and personal physician to Erasmus, Paracelsus was sufficiently far ahead of his time to give a new direction to both science and medicine. The father of anesthesia and modern chemistry and the discoverer of the sympathetic nervous system, Paracelsus (whose given name was Phillipus Aureolus Theophrastus Bombastus von Hohenheim) was born the year after Columbus discovered America.

Much of the scientific exploration that Paracelsus undertook was grounded in philosophical and metaphysical speculation. He believed that the stars and other astronomical bodies influenced not only magnets but the sympathetic nervous system as well. This influence was accomplished by means of a subtle emanation, or fluid, that pervaded all space.

Paracelsus practiced medicine within a theoretical framework that included a universal essence, the *archaeus*. Something like Plato's ideal realm, the *archaeus* made up the invisible

Paracelsus

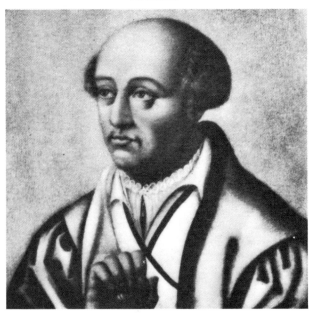

body of all beings. Ethereal in nature, the invisible body was the shadow counterpart of the physical body. Strangely, these speculations paralleled the Yogic philosophy of the East of the subtle or astral bodies, a system of ideas to which, apparently, Paracelsus was never exposed.

Like prana, the *archaeus*—or essence, as he described it—was equally distributed in all parts of the body: "If the body is in a healthy condition, it is the archaeus which is an invisible nutriment from which the visible body draws its strength, and the qualities of each of its parts correspond to the nature of the physical parts that contain it."[1] This description is markedly similar to the ancient Chinese concept of *ch'i.*

Paracelsus further described the visible world as the "Microcosm," which was "potentially contained in the *Liquor Vitae,* a nerve fluid . . . which contained the nature, quality, character and essence of all beings."[2] According to Paracelsus, disease could be treated by *munia,* a magnetic influence of vital force that could be brought to bear within the microcosm. This vital force "was not enclosed in man, but radiated within and around him like a luminous sphere and it may have been made to act at a distance."[3]

Paracelsus spun a web of ideas that has accompanied humanity throughout its history. The concept of a vital force that surrounded a person, that might have flaws that were the cause of disease, and that could be made to influence the state of being of other people is the framework within which all traditional healing concepts lie.

Just what is the radiating vital force Paracelsus talked about? It seems to have been a capsule description of the human aura.

Universal Magnetism

In the century following that of Paracelsus, a Flemish physician, Jan Baptista van Helmont, envisioned a "universal fluid," or force, that pervaded all of nature and that could not be separately measured or weighed. He described this universal fluid as "a pure vital spirit that penetrated all bodies and acted upon the mass of the universe."[4]

Intrigued by magnetism, van Helmont defined it as "occult influences which bodies often exert toward each other at a distance whether by attraction or impulse."[5] To him, the universal fluid exhibited itself through a "universal magnetism" that united all phenomena.

Van Helmont's theories show how the life-energy concept was often adapted to the language or framework of a given historical period. In van Helmont's time, the concepts assumed the cloak of magnetism, just as in later years they would be spoken of in terms of electricity.

"Life Beams"

Moving into the early seventeenth century, we find another life-energy theorist, Dr. Robert Fludd. He believed that life energy entered the body through the breath and emphasized the

power of the sun as a "purveyor of life beams required for all living creatures on earth."[6] In addition, this English physician, mystic, and alchemist postulated an invisible, supercelestial force manifesting itself in all living creatures. Fludd further believed that all human beings possessed magnetic qualities.

Dr. Fludd utilized these theories, which recall ancient Chinese *ch'i* and latter-day radiation concepts, in his medical practice. And by the late eighteenth century, an actual medical clinic was established in Vienna to treat disease through magnetic healing.

"Animal Magnetism"

Under the direction of Anton Mesmer, the Austrian clinic attempted to change European medical theory. "Everything in the universe," Mesmer wrote, "is contiguous by means of a universal fluid in which all bodies are immersed."[7]

Mesmer demonstrated a method of using "magnetic passes" (with iron rods) that had both

Franz Anton Mesmer

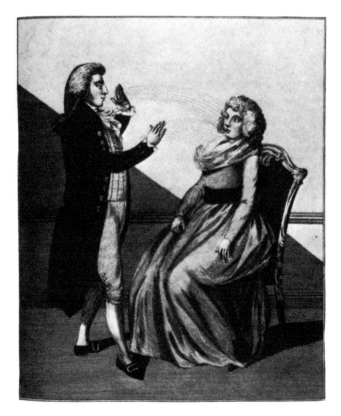

a hypnotic and healing effect on his patients. He claimed that "all things in nature possess a particular power, which manifests itself by special actions on other bodies."[8] To Mesmer, this was nothing less than a "magic fluid."

Mesmer postulated a theory of "animal magnetism." This theory stated that animal magnetism exists within the body and can be activated by a magnet or by magnetic passes. According to Mesmer, animal magnetism (as distinct from mineral magnetism) operates at a distance and can be accumulated, stored, and transferred to both animate and inanimate bodies. He also suggested that this force is reflected by mirrorlike light and can be increased by sound. Mesmer contended that it can cure nervous disorders, be utilized in both diagnosis and prevention, and is an indicator of vitality.

In 1784, however, a scientific report issued by the French Academy of Sciences, including the United States ambassador, Benjamin Franklin, discredited "magnetic healing" and branded Mesmer a quack. Mesmer died in 1815, disillusioned and ridiculed. Franklin went on to be hailed as the discoverer of electricity—a "universal fluid" that figured prominently in Western life-energy theories.

Life-force

About the same time as Mesmer, Luigi Galvani, an Italian physician, proposed an energy specific to living matter. Galvani used the term "life-force" to refer to animal electricity because it exhibited properties different from those of ordinary electricity. These properties, as noted by Galvani, included the functions of contraction and expansion. This life-force circulated within the system of an organism and maintained a complex relationship with atmospheric electricity. Unfortunately, because he lacked sophisticated instrumentation, Galvani could only suggest the existence of electromagnetic fields within organisms—a theory that science has just recently begun to probe.[9]

Odic Force

Further enhancing Mesmer's work, Karl von Reichenbach, a German industrialist, chemist, and the inventor of creosote, spent over thirty years investigating a universal energy he termed "od," or odic force. Reichenbach's research began after he discovered that "a strong magnet, able to lift ten pounds, when passed along a person's body often produced unusual sensations, including a feeling of cold air or of pulling or drawing."[10] Reichenbach found that the people most easily affected by these sensations were emotionally disturbed individuals. Those reporting the strongest effect from magnets, he called "sensitives." Under quiet, calm conditions, sensitives were able to see flames, sparks, rays of light, and white clouds emanating around the poles of strong magnets. And in darkened rooms, sensitives could see similar emanations issuing from human fingertips.

In 1845, Reichenbach published *Researches on Magnetism, Electricity, Heat and Light in Their Relations to Vital Power*. The product of thirty years' research, his findings were generally ignored, and the odic force failed to stir the mainstream of scientific inquiry. Reichenbach's general findings can be summarized as follows:

Odyle, or odic force, is a universal property of all matter. Its distribution in time and space is variable and unequal. It fills the universe and cannot be eliminated or isolated (making it almost impossible to measure). It flows from such sources as heat, friction, sound, electromagnetism, light, planetary bodies, chemical actions, and the organic activity of plants and animals, especially man. This force is polar. Negative odyle gives a sensation of coolness and is pleasant, whereas positive odyle gives a sensation of heat and is uncomfortable. Objects can be charged with odyle by contact. To sensitives, odic forces are luminous. Negative force is blue, and positive is yellow-red. These energies are particularly obvious around magnets. Reichenbach believed humans to be containers of odyle. He noted that the luminous odic force shifted during every twenty-four-hour cycle, much like the *ch'i* energy of acupuncture.

The Human Aura

Shortly after Reichenbach's death, the prodigious Nikola Tesla discovered the nature of the rotating magnetic field. According to a biographer:

Nikola Tesla holding the gas-filled, phosphor-coated wireless light bulb he developed in the 1890s to replace the incandescent lamp, which he considered inefficient

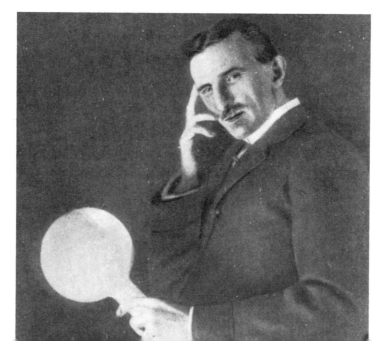

On that fateful afternoon in February in Budapest in 1882, when he was given the vision of the rotating magnetic field, there had come with it an illumination that revealed to him the whole cosmos, in its infinite variations as a symphony of alternating current. For him the harmonies of the universe were played on a scale of electrical vibrations of a vast range in octaves. In one of the lower octaves was a single note, the 60 cycle-per-second alternating current, and on one of the highest octaves was visible light with its frequency of billions of cycles per second.[11]

The first to harness the field's power, Tesla built the first alternating-current motor, AC generator, high-frequency coil, and transformer. Tesla was also the first person to expose film and photographic paper with high-frequency, high-voltage fields.

The advent of Tesla's inventions sparked many important discoveries in the field of biological energy. One of these was made by Wilhelm Roentgen, a medical researcher at Saint Thomas Hospital in London, who pioneered scientific research on rays of an unknown origin, which he dubbed X rays. He found them to have among the shortest frequencies in the electromagnetic spectrum. As we all know, the X ray has become a commonplace diagnostic tool in medicine.

Unlike the X ray, other electromagnetic research at Saint Thomas Hospital was to remain virtually unknown. For example, one colleague of Roentgen's, Walter J. Kilner, actually explored aspects of the human aura.

A medical electrician and member of London's Royal College of Surgeons, Kilner published a book based on four years of hospital experiments. It is to be noted that prior to the book's publication, Kilner had never expressed any interest in the psychic realm. Yet in his book, *The Human Aura,* Kilner speculated that magnetic radiations might be perceptible to sensitives (as discovered by Mesmer and Reichenbach) because the radiation might belong to the ultraviolet frequency, outside the range of normal sight.

To bring the emanations of the human aura within the range of normal vision, Kilner constructed colored screens consisting of optically ground glass cells containing an alcohol solution of dicyanine, a coal-tar dye. By training with these screens, Kilner believed that anyone could see some of the human aura.

Kilner theorized that this was possible because the screens affected the night-seeing nerves of the retina—called retinal rods—enabling one to see shorter wavelengths than one could ordinarily manage. To Kilner, the aura was an objective emanation that 95 percent of the population could see, if they so desired, merely by using his special screens.

The human aura, according to Kilner's findings, appeared as a faint, colorful, and luminous mist surrounding the body and extending about eighteen inches to two feet in all directions: "When the pole of a magnet was brought near, a ray seemed to be formed temporarily which joined the pole to the nearest or most angular part of the body."[12] (See Plate 10.)

The aura seemed to contain three definite zones: "The first was a dark edging, half a centimeter wide, surrounding the body; this was the 'etheric double.' Outside this, was the interior aura, dense and streaked perpendicularly to the body; this was from three to eight centimeters in width. Finally came the exterior aura, which had no definite contour."[13]

In addition, the aura seemed to vary according to the age, sex, mental ability, and health of the subject being observed. Color also varied, and blue seemed to dominate.

Like those of Reichenbach, Kilner's discoveries were ignored by his contemporaries. Noting that the misty emanation varied in shape and clarity from day to day and appeared faint and obscure during illness, Kilner formulated an elaborate system of medical diagnosis on the color and texture of patients' auras.

As we shall see, only recently have these conjectures been duplicated with Soviet and American experiments utilizing Kirlian photography.

N Rays

In 1904, Professor Blondot of the University of Nancy received the Lecompte prize of 50,000 francs for his description of N rays, previously unknown forms of radiation common to both organic and inorganic matter. Blondot theorized that magnets, chemical reactions, the sun, plants, humans, and lower animals all emitted short-band radiation, labeled N rays, and that metals in a certain state of molecular equilibrium also emitted these rays.

In his study of human radiation, Blondot noted that increased concentration and mental activity produced greater quantities of these rays. He also noted that N rays could be excited to luminescence. And, coincidentally, many of Blondot's findings suggest a close parallel to Reichenbach's study of the odic force.

At the turn of the century, radiation studies, still in the infancy of Roentgen's X ray and the Curies' discovery of radium, held a fascinating promise for Western science. What mysteries might lie hidden in the newly discovered sea of radiation that formed the background for the known universe?

Hidden Forces

Émile Boirac, rector of the Academy at Dijon, France, psychologist, and philosopher, embodied the spirit of speculation in his work *Our Hidden Forces,* published in 1915. Boirac explored and speculated on the dynamics of an invisible force common to both human life and magnetism. "The human organism can exert from a distance," Boirac wrote, "an action analogous to physical forces like heat, light, electricity and magnetism, upon other human bodies, and even upon material bodies."[14] He theorized that some unknown form of radiation

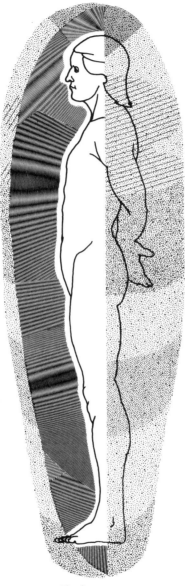

The human aura

permeated human life and was within the theoretical grasp of science. According to Boirac, science might begin to chart the effects some people exert on their fellow beings within the confines of a new branch of physics.

Boirac classified four different types of these influences exerted by people, including radiation properties that enabled some people to force their wills upon others. He suggested that perhaps a form of radiation would even explain the phenomenon of charisma. Other classifications included individual abilities, which in their concentration would cause paranormal sense experiences such as mediumship. Like Blondot's, Boirac's work was confined to theory and speculation. While the work of both these individuals may have acted as inspiration for other researchers, the actual development of bioenergetic concepts was left in other hands.

Invisible Emanations

Erich Konrad Müller, a geophysicist and engineer from Zurich, provided important groundwork for the maturing of the growing bioenergetic hypothesis. Müller published his findings in 1932, advancing the work of those who had gone before him, with tangible proof of human energy systems. According to the English *Journal of Paraphysics,* Müller "discovered that energy emanating from man under certain circumstances and certain conditions of health can be conducted along a wire . . . affecting photographic plates."[15] Müller found that this energy varied and that tea and tobacco stimulated the quality of radiation. Müller also found a correlation between electromagnetic emanations and the action of the breath. Again, the ancient concepts of *ch'i* and prana were objectified, this time by Müller's work.

L-Fields

Following Müller's work, Dr. Harold Saxon Burr, a leading professor of anatomy and biology at Yale University, began a thirty-year investigation into life energy. Along with Dr. L. J. Ravitz, a psychiatrist, Burr pioneered research into the electrodynamic aspects of human life and that of plants and other members of the vegetable kingdom. Their findings suggested that all organisms are, in fact, electrodynamic systems and that all life responds to electrical fields that exist both within and without the organism. They found that specific strains and species had their own characteristic voltage patterns and each seemed to possess a unique electromagnetic signature. These patterns were called L-fields, or "fields of life."

Burr and Ravitz correlated the intensity of electromagnetic fields, or L-fields, with human emotions, states of health and disease, aging, and hypnosis. Controlled investigation linked many disorders with shrinkages in the extent of L-fields. Sample disorders investigated ranged from peptic ulcers to cancer, with an unhealthy person or organism exhibiting radiation fields different from those of a healthy one.

Plate 1.

Voltage-sensitive emulsion, a photograph that captures the electrical field pulsed through color film.

One finding explained that "ovulation in women and certain nonhuman organisms that ovulate can be electrically detected, even from the fingers and even though there are no direct pathways leading from ovaries to fingers."[16]

In his article "Bioelectric Correlates of Emotional States," Ravitz made reference to "electric tides" in the atmosphere—for example, from the sun and moon—and their influence on organisms. "Thus with humans," he wrote, " 'steady-state' potentials generally increase occurring approximately at the time of the full and new moons, usually preceding or following the lunar day by 24 to 72 hours."[17] Humans not only exhibited characteristic electromagnetic fields, but these fields interacted with the prevailing electromagnetic characteristics of their environments.

Orgone Energy

One of the most controversial theories of life energy was developed by Wilhelm Reich. Although Reich was criticized for his radical beliefs, many of the techniques he developed, such as bioenergetics and structural integration, have been assimilated into the mainstream of popular psychology.

A trained physician and psychiatrist, Reich was a student of Sigmund Freud. Early in his career, he split with Freud over the central issue of sexuality. Freud held that the instinctive urges, such as sex, had to be acculturated and socialized. Reich felt that all levels of oppression, such as racism, nationalism, sexism, economic and social pressures, created an "emotional plague" that manifested itself in the individual as blocked or repressed energy.

For Reich, all life was a biological expression of a cycle of excitation, charge, discharge, and relaxation. However, the emotional plague reinforced the constant excitation and charge phases without allowing the possibility of a healthy, loving means of discharge.

Reich viewed most people as being overcharged with repressed biological urges, producing an "armor" in the muscles. To deal with this muscular armoring, he developed therapeutic techniques.[18]

All of Reich's work was based on the concept of the orgone, a universal energy permeating both the universe and living organisms. Present everywhere, orgone energy had no mass and was difficult to measure. In constant motion, the orgone also functioned as a medium through which all energy forms moved and exerted force.

Reich described the orgone as responsible for the phenomenon of life. Through a process of change, matter is created from orgone energy. Orgone energy forms units of creative activity called bions. Other units may be called cells or organisms. Separate streams of orgone energy may be attracted to one another and then superimposed on each other. Reich thought that orgone energy could be controlled.

Plate 8.

A beautiful and unusual interaction photograph showing a live coleus leaf, held in position by its owner/grower.

While the scientific establishment balked at his postulation of a basic life energy, Reich constructed devices to manipulate and control orgone energy for therapeutic purposes.[19]

Mitogenic Radiation

In 1937, Russian scientist Alexander Gurvich discovered a new form of invisible radiation. He found that all living cells, especially those in human organisms, produced a type of radiation, called mitogenic radiation, found in muscle tissue, blood cells, nerve cells, and in the cornea of the eye. He also determined that illness affected the quality and quantity of mitogenic radiation.

Gurvich suggested that "the rays [of radiation] seem to be given off most strongly by the parts of the organism which are replaced most rapidly—such as the palms of the hands and the soles of the feet."[20] Noting something in common with Reich's theory of the orgone, Gurvich found that the sex organs in both sexes and the breasts in women emitted the rays quite strongly.

PHOTOGRAPHING LIFE ENERGY

Each age has produced comprehensive theories about life energy. Many of these theories, from Paracelsus to Reich, bear startling similarities. Life-energy systems also parallel the ancient folk concepts that permeate all cultures throughout the globe. Obviously, life-energy concepts are persistent, seeming to accompany humanity in its effort to understand the universe.

In 1939, the history of life energy took an unexpected turn with the investigations of Drs. Silvester Prat and Jan Schlemmer at Charles University in Prague. Their findings described an experimental photographic process, called electrography, that used a high-frequency electrical field to expose standard film.

Prat and Schlemmer photographed the electromagnetic radiation that later formed the basis of modern life-energy theories. Photography was soon to become the most important tool for detecting and measuring life energy. Although the preliminary research of Prat and Schlemmer was unusual, they did not continue their research. Fortunately, the photographic process was pursued by a husband and wife research team in the Soviet Union, Semyon and Valentina Kirlian. The process that bears their name, Kirlian photography, has come to be synonymous with our present exploration of life energy.

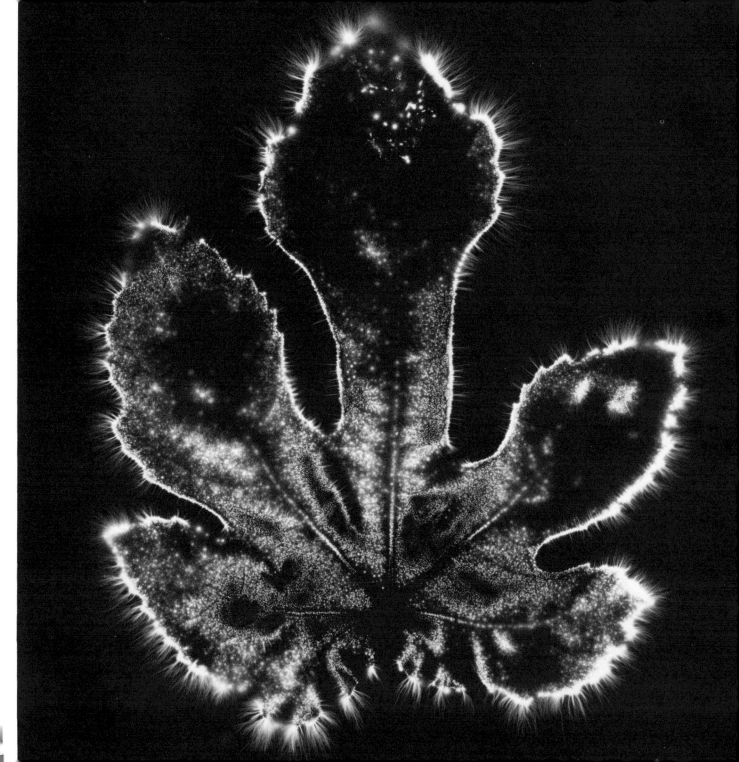

3

What Is Kirlian Photography?

It is possible that there exist human emanations which are still
unknown to us. Do you remember how electrical currents and
"unseen waves" were laughed at? The knowledge about man
is still in its infancy.

—Albert Einstein

Like many important discoveries, Kirlian photography was the result of an accident. It is
reported that Semyon Kirlian, an electronic technician, was called to a research institute to
repair an instrument. It was there that he witnessed a patient receiving electrotherapy treat-
ment. Noticing that there were tiny flashes of light between the metal electrodes and the skin
of the patient, Kirlian wondered if he could produce a picture of that interaction by placing
a photographic plate between the skin and an electrode. Although he received a severe burn,
Kirlian's photographic results (with himself as the subject) consisted of a "strange imprint, a
kind of luminescence in the shape of the contours of his fingers."[1]

Joined by his wife, Semyon Kirlian spent the next ten years developing instruments through
which the interaction of high-frequency currents and photographic plates could be observed
with humans, plants, animals, and inanimate matter. By 1949, the work of the Kirlians began
to attract the interest of biologists, botanists, physicians, and members of other scientific
specialties.

MANY DIVERGENT VIEWS

Although the Kirlians developed the process in 1939 and serious research on a wider scale
began in the Soviet Union in 1949, Kirlian photography was not investigated in the United
States until the 1970s.

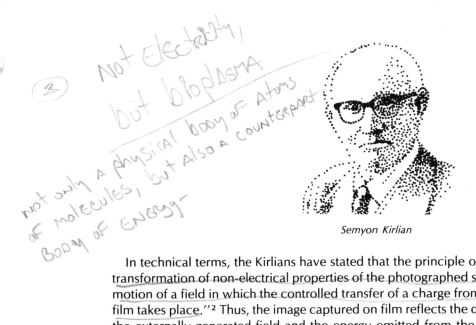

Semyon Kirlian

In technical terms, the Kirlians have stated that the principle of Kirlian photography is "The transformation of non-electrical properties of the photographed subject into electrical ones via motion of a field in which the controlled transfer of a charge from an object to a photographic film takes place."[2] Thus, the image captured on film reflects the dynamic relationship between the externally generated field and the energy emitted from the subject.

Through their years of research, the Kirlians have noted patterns that consistently manifest themselves in this dynamic relationship of energies. From the beginning of their research the pictures they produced were not uniform. They varied with changes in the characteristics of the photographed object. "For example, those leaves photographed soon after being picked, were showing a very sharp, clear and definite image and a certain energy field. But after an interval of an hour, the field was quite different—that is, always smaller."[3]

They also noted that in humans the heart region is consistently blue, the forearm green-blue, and the thigh olive. "These inherent colors are reproducible under similar conditions. There is reason to assume that during unexpected emotional experiences (like fear or illness), the inherent color in a section changes."[4]

Dr. V. M. Inyushin, a Soviet biologist at the State University at Kazakhstan, studied the Kirlian process to determine exactly what was being photographed and what the implications of the process were. Inyushin stated that the bioluminescence revealed in the Kirlian photographs was not caused by electricity. Instead, the phenomena were part of a previously unknown property of living organisms, called bioplasma. "All living things," Inyushin wrote, "not only have a physical body made of atoms and molecules, but also a counterpart body of energy."[5]

Initially, Inyushin conceived of this energy body as similar to the aura or astral body as defined, for example, in Yogic literature. This same concept permeated spiritual movements and it is this aspect of Kirlian research that has created the most controversy and debate.

Since there are no nonmaterial phenomena or metaphysical properties in a Marxist view of the universe, Soviet researchers like Inyushin have been more free than their Western colleagues in pursuing these lines of speculation. Inyushin claims that bioplasma is made up of

freely charged particles that exist in organized patterns and create uniform energy networks. However, because the nature of these particles is such that the bioplasmic energy body is sensitive to magnetic fields, changes in temperature, and other environmental influences, it is naturally unstable.

Inyushin further believes that the bioplasmic energy body, as revealed in Kirlian photographs, reflects both the psychological state and physical health of human beings. "All the psychic, as well as physical states of an animal are reflected in the total energetic state of its plasma."[6]

Another Soviet researcher, Dr. Viktor Adamenko, has also written on the Kirlian process. Unlike Inyushin's, Adamenko's theories avoid the energy-body hypothesis. He believes the Kirlian process is a "cold-emission of electrons," and that by studying these emission patterns as they appear on the film, he can obtain pertinent and as yet unknown information about the nature of both organic and inorganic material and the dynamic process of living organisms.

American scientists who have explored the Kirlian process display a range of opinion similar to that of their Soviet colleagues. For example, Dr. William Tiller of Stanford University believes that Kirlian photographs can be explained by conventional concepts of the physics of coronal discharge.

Tiller feels that the emanations surrounding the photographed object are simply an electrical phenomenon due to the interaction of electrons pulsed through the object and the photographic film. While this argument does not account for the way that Kirlian photographs vary with changes in emotional states, Tiller concedes that "mental or emotional states are known to influence the skin's surface chemistry and electrical impedance, two factors that could be expected to alter the character of the discharge."[7]

In contrast to Tiller's orientation in physics, Dr. Thelma Moss addresses the Kirlian question from her experience as a psychologist. One of the first American scientists to travel to the Soviet Union to investigate Kirlian research, Moss has compiled thousands of Kirlian photographs of plants, animals, human interaction, and even altered states of consciousness. She feels that the Kirlian process may have direct application in the field of human relations by revealing the nonverbal dynamics that flow between people.

Moss has developed a sense of the vast possibilities of Kirlian photography. Regarding Kirlian photographs of meditating subjects, she commented: "By bringing meditation into the laboratory . . . we may find ourselves exploring strange, at first incomprehensible, dimensions of experience . . . a different dimension of being, transforming from material man into the man of the spirit."[8]

What impresses Alberto Zucconi, an Italian researcher and an associate of the Heuristic Institute in California, is the diagnostic potential of Kirlian photography. "What is interesting," he notes, "is that this process is valid at the diagnostic level. We are not so much concerned with which theory is confirmed, as to notice the changes and to record these."[9] Like Moss,

Zucconi feels that the greatest promise of Kirlian photography lies in its ability to reveal objectively the internal mental states of people.

Another perspective of Kirlian photography is held by Kendall Johnson, the first American to build a Kirlian apparatus. To Johnson, the Kirlian process is "photographing the non-material reality."[10] He speculates: "Perhaps this type of exploration will give us a more informed sense about the possibility of the existence of an invisible energy system. Perhaps it will give us insight into the possibility of a non-material organization of life."[11]

ENERGY IN TRANSLATION

There are many explanations of Kirlian photography, from the totally physical to the non-material perspective. Yet these are only models, theories, or mere speculations at best and therefore should not be confused with the actual dynamic phenomena they attempt to describe. Only the photographic images are *real,* for they offer documentary evidence of the pulsating charge and discharge of life's energies.

Many researchers agree that Kirlian photography reveals subtle and very complex networks of energy, much like those we see when looking at living cells through a microscope. The life process can be seen as energy and matter in translation.

The recent invention of Kirlian photography has produced great controversy around the idea (indicated by notions like the nonmaterial organization of life and the bioplasmic body), that Kirlian photography may be colorfully depicting life energy. Traditionally, the physical scientist has viewed life as having energy, but not considered this energy to be "alive." It might be argued that it is more important to understand the interconnections of energy and matter than to consider whether energy emanations or patterns are "alive." By expanding our knowledge of the interconnections of energy and matter, we move closer to a clearer understanding of Kirlian photography.

Think of the Kirlian process as similar to turning on an electric light. When electricity is applied, a form of matter (like tungstan) becomes excited. All shapes, sizes, and configurations of matter are already in constant vibration. The Kirlian apparatus creates similar excitation of matter as it vibrates and glows. This is particularly true when the frequency rate of the external energy is at or near the resonant frequency of the object photographed. "Resonance" means simply that each physical structure has a fundamental note or vibration. When external energies begin to approach this fundamental note, the structure's inner vibration increases violently in intensity. If the transmitted note or vibration is amplified sufficiently, the physical structure may disintegrate. An illustration of this is the singer who breaks a glass by singing the resonant frequency of its crystal structure.

Graphic illustration of cymatics (the relationship of waveform and matter)

Although living substances may respond to external vibrations directly, more often they react by vibrating in sympathy. The energetic patterns revealed by Kirlian photographs of human fingertips visually illustrate how living matter responds in sympathy to the waveform generated. Perhaps through studying the relationship of waveforms and matter, significant information can be gathered about the dynamic vibrations of life. The newly developed science of cymatics was especially designed to explore this relationship of waveform and matter.

Before Kirlian photography, vibrational patterns were observed by putting sand on a metal disk while a stringed instrument such as a violin was played. Ernest Chladni, an eighteenth-century German physicist and photographic artist, performed the original cymatic investigations. As a result of more recent experiments, Hans Jenny, in his book *Cymatics,* noted the incredible interconnections between external waveforms and matter.[12]

Jenny also used disks, which were scattered with plastics, liquids, powders and metal filings. ''He then vibrated the disks through the controlled medium of a crystal, observing that as the pitch ascended the musical scale, the harmonic patterns on the disks also changed, many of them to organic shapes: The vanishing spirals of jelly-fish turrets, the concentric rings in plant growth, the patterns of tortoise-shell or zebra stripes, the pentagonal stars of sea-urchins, the hexagonal cells of the honey-comb, etc.''[13]

This cymatic perspective can help us visualize the world of wave phenomena and vibrations so beautifully displayed through the Kirlian images. From this perspective, the entire universe, whether at the cosmic, biological, or molecular level, can be observed as a complexity of waveforms whose frequencies may range from millionths of a cycle per second to cycles millions of years long.

The recent development of Kirlian motion pictures, rather than conventional static images, demonstrates that the complex process of waveforms and matter is actually in continuous motion. When this dynamic process is viewed at the subatomic or particle level (electrons or plasmic particles), a most basic interconnection of matter is revealed, ''showing that energy of motion can be transformed into mass, and suggesting that particles are processes rather than objects.''[14]

When the causes of Kirlian photography are perceived from this point of view ''there are no fundamental laws, equations, or principles . . . simply the interconnections of matter and energy.''[15] Matter then becomes ''energy knots'' in space, a fascinating dance of infinitely joining particles.

The Kirlian aura appears alive with color, mirroring the dynamic energy relationships within

and between living systems. These images reflect the intricate workings of the universe and may help us to uncover some of the complex vibrations of energy involved in the life process and other natural phenomena.

Alan Watts, philosopher and cosmologist, observed the vibrations of life without the aid of Kirlian photography: "The cosmos is a complex, multi-dimensional system of vibrations arranged in criss-crossing spectra, as in a weaving, and from these as in playing a harp—we pluck and choose those that are to be considered valuable, important or pleasant, ignoring or repressing those which we deem unimportant."[16]

At this early stage in the development of Kirlian photography it seems important to *suspend judgment,* while openly considering all its possible interconnections and future applications. By establishing this more wholistic perspective we may begin to overcome some of the fragmentation and compartmentalization of traditional scientific thought. Yet in the final analysis we all individually decide which perspective is "right" and which is an illusion. Kirlian photography might be the missing key to understanding that the entire universe is *energy in translation.*

Photographs of Uri Geller's aura, produced by Uri Geller in energy interactions.Left: Taken after a watch "supplied by one observer" and the subject's fingertips were placed a few inches apart on the film. This was the control photo. Right: The watch and fingertips were placed as before but the subject was concentrating on "shooting energy toward the watch" (subject's words). The evidence of these experiments should be considered preliminary and tentative.

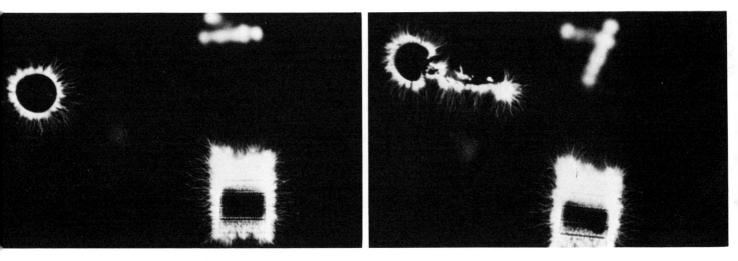

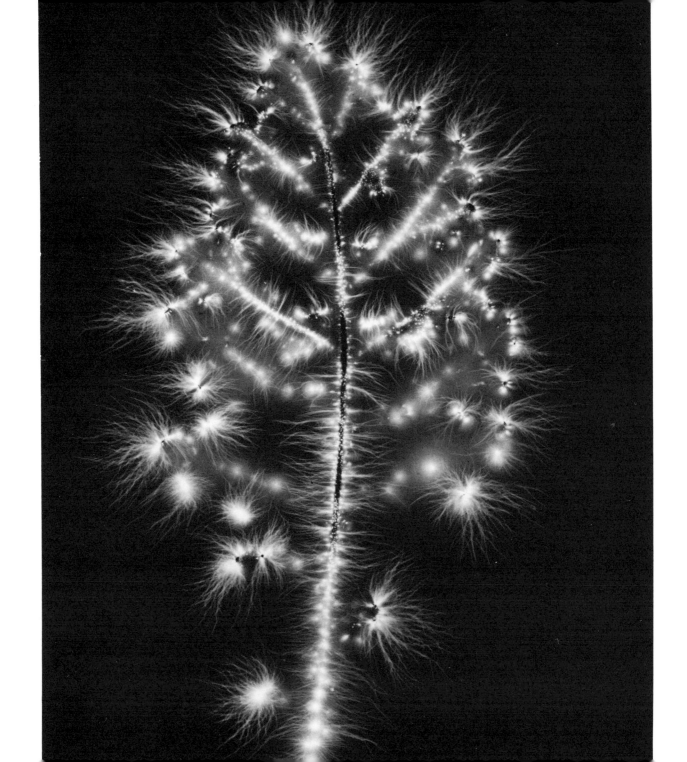

The Promise of Kirlian Photography

> Science is the art of creating suitable illusions which the fool believes or argues against, but the wise man enjoys for their beauty or their ingenuity, without being blind to the fact that they are human veils and curtains concealing the abysmal darkness of the unknowable.
>
> —Carl Gustav Jung

PLANT RESEARCH

Of all the ways man has devised to study the complex interaction of plants and the environment, the one that holds the most promise is Kirlian photography. In fact, Semyon and Valentina Kirlian began some of their studies with plants. In an early experiment they were given two "identical" leaves to photograph. Unknown to the Kirlians, one leaf was diseased. The disease showed up on the resulting photographs, which should have been identical (see Plate 10). From this small beginning, the Kirlians developed methods of detecting plant diseases before visual symptoms became apparent.

Current plant research with Kirlian photography was pioneered at UCLA. Dr. Thelma Moss's research team discovered that a simple scratch with a needle would produce a large red blotch on the scratched area of a leaf's Kirlian photograph. Moss labeled this the "bleeding-leaf effect."

Other dramatic experiments were undertaken with a famous psychic healer, Olga Worrall.[1] She would only have to pass her hand over a gashed bleeding leaf to effect an immediate cure. The leaf's Kirlian energy photograph showed the red blotch disappearing and the energy and original color returning to the damaged part of the leaf.

Moss calls this healing process an aspect of the so-called green-thumb effect. An opposite effect on plant life, known as the "brown-thumb effect," was demonstrated by Barry Taff, an associate of Dr. Moss's. When Taff passed his hand over a leaf, the leaf turned brown, shriveled up, and died.

Other recent experiments involved Reich's orgone accumulator. Leaves kept in an orgone box (a metal container consisting of layered steel wool and cotton) had fuller Kirlian energy patterns than control leaves kept in similar boxes without the accumulator apparatus. Green thumbs, brown thumbs, and the presence of orgone energy are effects that were once the sole province of hearsay and myth. Today, Kirlian photography offers ways actually to document aspects of man's profound relationship with the vegetable kingdom.

One of the most controversial aspects of Kirlian research concerns the so-called phantom-leaf effect, in which intact images of the energy body of a whole leaf appear after parts of the physical leaf have been cut away (see Plate 5).

One of the first "phantom leaves" was photographed by Viktor Adamenko. His experiment was confirmed in other laboratories in São Paulo, Brazil. Brazilian scientists H. G. Andrade and Luis Zanin maintain that they have "not only taken several phantom leaf pictures, but have captured the image of a phantom salamander limb as well."[2]

The first American phantom leaf was captured at UCLA by Kendall Johnson. Johnson and his associate, John Hubacher, have produced several phantom-leaf photographs with the aid of the Kirlian process (see Plate 5). Another phantom leaf was recently photographed by Robert Wagner at California State University at Long Beach (see illustration p. 47). An affiliate of the Heuristic Institute, Richard Peterson, also captured a partial phantom image after the leaf was dissected (see Plate 4). At present, the existence of the phantom-leaf effect is still controversial. Researchers agree that only one out of every four hundred attempts will yield a clear phantom. Many variables come into play. For example, the photograph must be taken within seconds of cutting the leaf. For those who accept the existence of the effect, debate still ranges over its cause and implications. As more phantoms are produced in laboratories throughout the world, the effect will undoubtedly gain credibility.

One implication of the phenomenon suggests that the bioplasmic energy body, although interrelated with the physical organism, somehow exists in a separate reality that extends beyond ordinary conceptions of space and time.[3] As in many other situations, Kirlian photography here suggests a range of possibilities, demonstrated technologically, that exist beyond our present scientific boundaries.

Yet the boundaries of conventional reality are constantly expanding. We are now beginning to accept a world view that includes complex dimensions of plant life and the ability of humans to "communicate" with plants. As John Lilly, specialist in interspecies communication, has

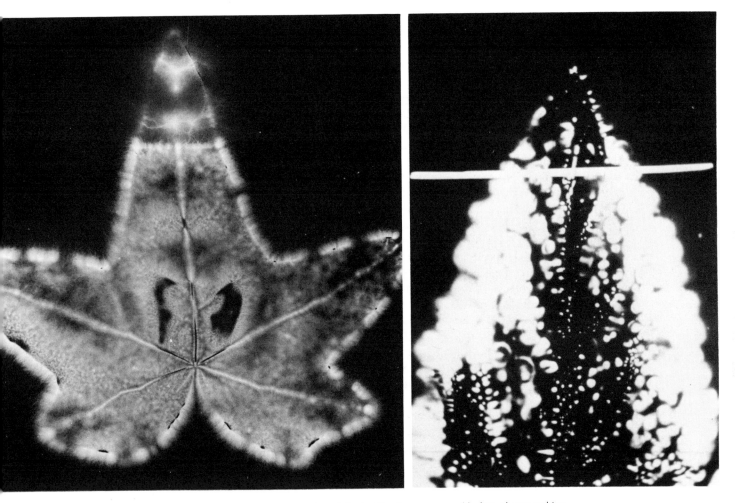

Phantom leaf effect. Upper portion of the leaf has been removed before photographing.

written, "Within the province of the mind, what I believe to be true is true, or becomes true, within the limits to be found experientially and experimentally. These limits are further beliefs to be transcended."[4] For in the realm of the mind, there are no limits. Kirlian photography extends the limits of our *experiments* and our *experience.*

MEDICINE AND WOUND HEALING

As an important part of plant research, does Kirlian photography also hold the promise of being an early warning system for human disease? Soviet biologist Dr. V. M. Inyushin observes: "Many diseases were shown to begin when the supply of bio-plasma deteriorated."[5]

Is Western medical science, then, on the verge of a new understanding of the healing process? Possibly, when we consider that Kirlian photography may offer science a tool to observe electrodynamic fields—complex energy systems surrounding all the life forms that play an important part in the natural healing process.

Because of this and other possibilities, medical research looms as the most important area of application for Kirlian photography. And contemporary researchers are already taking their first tentative steps into the uncharted territory opened up by Kirlian photography.

Still controversial, American Kirlian research lacks any known government support or private foundation grants usually reserved for more established fields of inquiry. In addition, there is poor communication between isolated researchers, plus the reluctance of Soviet government scientists to share their stored pool of thirty years' research with their Western colleagues.

So while the United States has not begun to use this research tool effectively on any scale approximating its potential, growing numbers of researchers are examining Kirlian photography's medical possibilities.

Cancer Detection

For example, one California team of researchers, headed by Thelma Moss, is pioneering cancer diagnosis studies. Moss, along with associates John Hubacher and Ted Dunn, the latter a pathologist at the University of Southern California, photographed tissue taken from human breasts. The cultures photographed ranged from normal to fatty to cancerous tissue.

The pilot investigations used the double-blind method; that is, the doctors who photographed the tissue samples and the doctors who subsequently diagnosed the cancerous tissue in the photographs had no previous knowledge of the types of tissue they were studying. Still, when the photographic results were displayed, the research team easily distinguished the Kirlian photos of cancerous tissue from those of normal tissue.

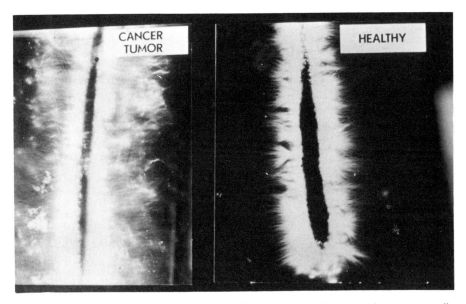

Kirlian photographs of rats' tails, one normal, the other after injection with cancerous cells

In another double-blind study, over a hundred pairs of healthy rats and rats that had been injected with carcinogenic substances were photographed. Again, photographs of the cancerous rats' tails were easily distinguished from those of the healthy ones. Moss's team stresses that more research is badly needed before any conclusions can be drawn, but the pilot investigations show significant diagnostic promise.

Meanwhile, a researcher in Bucharest reportedly has made a major breakthrough in human cancer detection, a breakthrough that has triggered a Rumanian government plan to launch nationwide screenings of the entire populace.

Dr. Ioan Dumitrescu, a chief aide in the Rumanian Ministry of Chemical Industry, conducted fifteen years of research during which he refined the Kirlian photographic process so that changes in the body's tissue formation could be detected through parallel electromagnetic changes.

He found that healthy tissue appears dark when photographed through his refined Kirlian process, while unhealthy tissue radiates a bright aura. His method appears especially useful for early cancer detection because he has managed uniquely to capture the auras of individual cells—making possible the detection of tumors in very early stages that are far too small to be diagnosed by conventional techniques.

R. S. Stepanov writes of this method: "By analyzing the energy and also geometry character-

istics of the high frequency discharge channels, and comparing these characteristics with those of normal (non-cancer) images, the Kirlian method allows us to judge not only how far the metastases have spread, but also the dynamics of malignancy."[6]

Dumitrescu found indications of malignant tumors in 47 out of 6,000 industrial workers who were screened in one test. Conventional tests confirmed that 41 of the patients had cancer, and Dumitrescu felt the other 6 would be diagnosed as cancerous when their tumors grew large enough to be detected conventionally.

The Rumanian government subsequently announced plans to screen all citizens electronographically at the same time they are X-rayed for tuberculosis.

Wound Healing

In other medical research, the Heuristic Institute recently began a pilot study observing the wound-healing process with Kirlian photography.

The simple cut, gradually healing day by day, is a universal testimony to the human body's inherent healing force. This simple and dependable process may actually be a complex interweaving of electrodynamic operations.

The colorful flare patterns revealed by the Kirlian process correlate with the electrodynamic fields that surround living organisms, and Harold Saxon Burr's work with L-fields has already suggested the profound influence of these fields on the growth and repair of living tissue.

Recent Soviet findings demonstrate that the healing process speeds up when a wound is sprayed with ionized air. In addition, Inyushin states that negative ions help restore the bioplasmic energy body to equilibrium. (The bioplasmic energy body is the theoretical entity photographed by the Kirlian process.)

Studies being undertaken currently at the Heuristic Institute couple a negative-ion generator with the Kirlian apparatus in an effort to duplicate the Soviet findings, as well as to monitor the effects of negative ions on fibroblast cell division. Attempts have been made to photograph both entire wound sites and the microorganisms known as fibroblasts, tiny microbes responsible for creating collagen fiber, the connective tissue in the wound-healing process.

TOBACCO-SMOKING STUDIES

Medical research using Kirlian photography has also been pursued in other areas. One recent pilot study initiated by the Heuristic Institute in December 1973 was designed to gain insight into the personal and physical effects of tobacco smoking.[7]

The study utilized various scientific instruments such as the electroencephalograph (EEG)

and the Kirlian photographic apparatus. The EEG found in most modern hospitals is a sensitive instrument that monitors changes in brain waves. Using the EEG in the study, measurements of dominant brain-wave frequencies were noted before, during, and after smoking tobacco. Additionally, a group of nonsmokers was observed in order to measure changes that might naturally occur during the time the study was being undertaken.

Results of the tests obtained from the tobacco smokers revealed that brain-wave frequencies (measured in cycles per second) slowed down.[8] This evidence, although taken from a small sample, may confirm various subjective reports of the psychological and physical effects of tobacco smoking; that is, smokers often claim that tobacco promotes a temporary slowing down or sensation of relaxation in the body and mind.

A Kirlian photographic apparatus was also used to detect subtle changes that might occur during and after tobacco smoking. Photographs of the right index fingertips of all subjects were taken after a five-minute period of smoking. The photographic results are displayed in Plate 11.

These preliminary findings demonstrated the presence of a large red blotch with a semi-kidney-shaped silhouette that appeared only in the fingertips of tobacco smokers. It appeared consistently just above the fingernail. In contrast, the photographs of nonsmokers revealed a clear, continuous, and symmetrical corona that freely radiated at ninety-degree angles from the fingertip.

It has been speculated that this large red blotch, which appears only in tobacco smokers, may possibly demonstrate a more general and well-known effect of nicotine—that of the peripheral vasoconstriction of blood capillaries. The body's physical reaction to nicotine would account for the resultant cold hands and feet often experienced by habitual tobacco users. Although other researchers have also speculated on this correlation of tobacco smoking and the red-blotch phenomenon, further study is strongly needed.

ACUPUNCTURE

As recently as 1970, the conventional wisdom of Western medical orthodoxy dismissed acupuncture as pure quackery.

—Dr. Irving Oyle, *The Healing Mind*

The recent introduction of acupuncture to Western medicine affords new opportunities to extend our knowledge of the human energy system. While pragmatic Western science has partially accepted acupuncture because it works, *why* it works is still the subject of debate. Fundamentally, acupuncture is based on the following belief:

The human organism is responsive to the total environment—that is, that a man is linked to a cosmic, vital energy. If there is a change in the energy envelope around a man, he will be affected by it; the vital energies in the body resonate to these changes, and they in turn affect the physical body. Specifically, then, acupuncture sees the vital energy flowing through the body along lines, called meridians, that connect organs with points on the skin's surface.[9]

How does an acupuncturist deal with disease? Dr. Louis Moss, author of *Acupuncture and You,* notes: "Medically, acupuncture concentrates on examining and probing the twelve fundamental meridians for an excess or deficiency of energy (an excess can be as serious as a shortage)."[10] As Irving Oyle points out, "Manipulating the energy changes the state of the internal tissue of organs fed by the meridian and healing can be achieved."[11]

Today, Kirlian photography is becoming an important tool for a Western understanding of traditional acupuncture. For example, a recent experiment at UCLA involved Kirlian photographs of a patient's foot before and after the acupuncture treatment of a chronic pain. The treatment site was an acupuncture point verified by extensive Chinese charts. Kirlian photographs demonstrated obvious emanation changes after acupuncture treatment.

Even though theories concerning acupuncture are still in the formative stage, a North Korean medical professor, B. H. Kim, has developed a scientific method for verifying the traditional acupuncture system. By introducing radioactive trace elements into human subjects, Kim

Acupuncture points

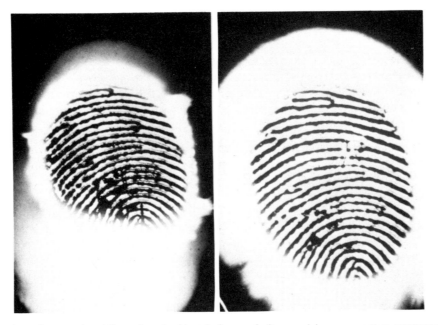

Kirlian photographs of fingertips of subject before and after receiving acupuncture treatment

found that the meridian system is independent of the nervous system; the meridian fluid flows from the acupuncture points inward to deeper ducts within the internal organs and corpuscles, and, finally, outward again.

Research at the Tucson Medical Center confirmed Kim's findings. The Arizona research describes the physical structure and composition of unsuspected "microtubules" that serve as transporting channels for *ch'i,* the invisible life energy once dismissed as a Chinese folk myth.

Furthermore, Stuart Hameroff, a member of the Arizona research team, published a study in the *American Journal of Chinese Medicine* ("Ch'i: A Neural Hologram?") asserting that these tiny tubes have remained undetected by the most advanced electron microscope–scanning techniques because the dyes used for staining tissue samples tend to dissolve the microtubules under scan. Hameroff's findings corroborated other aspects of the North Korean research. The microtubules contain high concentrations of the nucleic acids DNA and RNA.

Both acupuncture and Kirlian photography challenge the conventional, static perspectives of Western medicine, thus requiring new scientific models. Acupuncture studies can expand the basic understanding of health and disease in the human organism. The acupuncture model establishes disease as a loss of harmony between the antagonistic powers of yin and yang; harmony can be restored by the stimulation of acupuncture points that are located under the skin. Health becomes a balanced energy system.

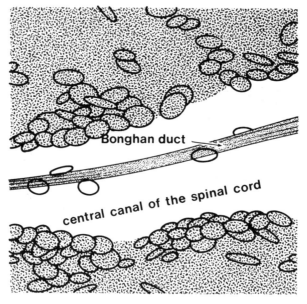

Graphic illustration of electron-micrograph

Kirlian photography offers science a method of charting this human energy system and its relationship to a fluid environment.

CAN SPIRITUAL HEALING BE PHOTOGRAPHED?

✳Traditionally, healing in all forms has been associated with religion. For most of history, the realm of healing has been the realm of the medicine man, the mystic, and the priest. Healing talents were demonstrations of a strong relationship to nature. Spiritual healers described their power as a vital life-force that flows through their bodies from above.

Rolling Thunder, a contemporary medicine man and Shoshone Indian spokesman, believes this life-force is contained in all matter: "Everything that has life also has an electrical force. The flow of energy has to be in certain directions, and if it gets unbalanced it can affect our bodies in such a way that we might become ill or even paralyzed. This energy flow in the human body is very important."[12]

It is this vital energy flow that allows healers like Rolling Thunder to channel (transfer) energy to a "healee." Often this process is accomplished through a laying on of hands. Dance rituals or other rhythmic movements are sometimes used by the healer to build up an energy charge before the process is begun.

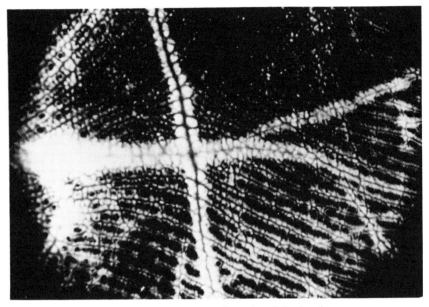

Acupuncture point on the palm of the hand

The Soviet Ministry of Health recently studied healer Colonel Alexei Krivorotov. Viktor Adamenko observed electrical discharges emanating from Krivorotov's hands as he began a healing process. The healees experienced mild shocks, feelings of warmth, and the flow of energy.

Kirlian photographs were taken before and after a healing. These photographs showed a large concentration of flare patterns along with changes in color during the healing process.

We have also conducted a similar study, but on a California healer, Reverend Harold Plume. Plume "inserted" his fingers into the healees. First, Plume scanned the body of the patient with his eyes. He then passed his hands over the patient and placed a piece of facial tissue over the external surface of the symptomatic area. As he peered through the tissue, he slowly straightened his fingers and pressed them against the patient's body. Plume's fingers seemed to disappear in the body, along with some of the tissue paper. Then, moments later, his fingers reappeared as they slowly withdrew from the body. There was no blood, incision, or scar tissue.

Kirlian photographs were taken of Plume's fingers, both before and after the healing of a young woman. She described medical evidence of lumps in her right breast. Before the healing, the Kirlian photographs of Plume's fingertips appeared concentric in pattern and blue and white. In all respects, ordinary Kirlian images.

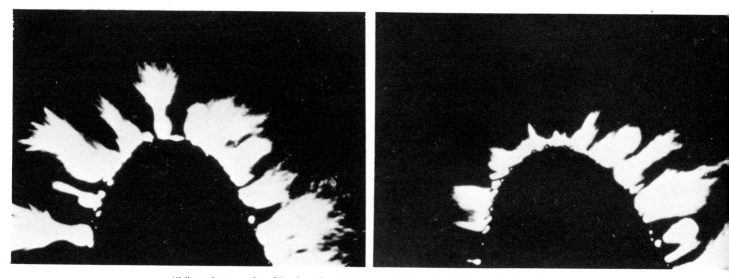

Kirlian photographs of healer Alexei Krivorotov's fingertips during and after a healing

However, immediately after the removal of his fingers, the pictures showed an internal mesh of starpoints of light covering the fingertips (see Plate 12). These changes corresponded to the sensations of warmth and energy described by the subject of the healing.

Another recent study involved Kirlian photographs of a Brazilian hypnotherapist, Aseso Monterio. Monterio was able to induce a trance state in subjects by moving his hands near the subjects and touching them on the back of the neck. Once this was accomplished, the healer would move his hands over the subject's body.

Kirlian photographs taken during this phase of the healing were similar to photographs of the Soviet subject Krivorotov and others, taken by E. Douglas Dean, of psychic healer Ethel DeLoach.[13]

Although documentation is scanty at this point, the controversial subject of faith healing may finally be capable of objective study through Kirlian photography.

PSYCHIATRY AND THERAPEUTIC ALTERNATIVES

If Kirlian photographs of the bioplasmic body can detect changes in the health or energy system of an organism before such changes manifest themselves in the physical body, as Soviet findings suggest, then Kirlian photography may become one of medicine's most valuable diagnostic tools. Drs. David Sheinkin and Michael B. Schachter, psychiatrists at the Rockland County Community Health Center in Pomona, New York, are conducting experiments to verify the Soviet findings.

Sheinkin and Schachter observed and photographed patients with pneumonia, gastroenteritis, and upper respiratory infections. Their tentative conclusions indicate that diseases exhibit consistent Kirlian aura patterns. For example, the aura of a specific gastrointestinal patient is easily distinguished from that of a patient suffering from another disease, such as pneumonia.

Psychiatric studies figure prominently in Sheinken's and Schachter's research. Their studies included alcoholic-psychotic, acute schizophrenic, and manic-depressive patients. The Kirlian photographs of one schizophrenic patient exhibited "a lack of clarity of the fingerprint pattern and a general absence of the surrounding corona during a severe acute episode."[14] Five days later, according to their research, when conventional chemotherapy had brought the symptoms under control, "The patient's fingerprint showed up on the photograph with increased clarity, and a corona was present."[15]

The Sheinkin and Schachter studies, among the first of their kind in the United States, establish the possibility of consistent auric disease patterns and point out the need for further research. As yet, the conclusions are still speculative. "We want to control a lot of factors," commented the research team, "such as the pressure of the finger and the gap between the film and the finger, to see if the Kirlian photographs reveal definite disease patterns and whether they might be used diagnostically and prognostically."[16]

Therapeutic Alternatives

Other studies have involved Fischer-Hoffman therapy, a practical and somewhat spiritual alternative to psychotherapy that is an eclectic mixture of contemporary approaches. The Fischer-Hoffman process utilizes psychodynamic, gestalt, and other holistic techniques in a thirteen-week program. Recently, the Heuristic Institute monitored coronal emanation patterns of Fischer-Hoffman participants before and after completion of their program.

One subject, a male in his early thirties, had just undergone the emotional trauma of a divorce. Before entering the program, he reported feeling anxious, pensive, and depressed. There seemed to be little "emotional content" to his life. Approximately forty Kirlian photo-

graphs were taken of parts of his hands and fingers. Consistently, a bright-red color with broken coronal patterns was observed emanating from all his fingers. However, shortly after the process ended, the subject reported having gained a more positive outlook, with increased physical energy and a greater acceptance of his emotional problems. These subjective feelings were translated into another dimension with Kirlian photographs. In striking contrast to the previous red, broken image, all postprocess photographs appeared blue, with entirely symmetrical coronal fields (see Plate 14). These results reflect a general color-pattern change often correlated with extreme emotional shifts.

INTERPERSONAL RELATIONSHIPS

As demonstrated by this last report, Kirlian interaction photographs visually display the fluid auras of people in relationship to one another. Changing patterns of relationships produce dramatically different photographs. Kirlian photographs of relationships demonstrate an unseen universe of human energy, a universe of communication that parallels the conscious thoughts and actions we direct toward one another.

Intimate, nonverbal communication patterns between people can be verified visually by the Kirlian process. According to a study undertaken by Thelma Moss, for example, close male friends who work together generate brighter, more convergent coronas than male strangers placed in similar situations. Furthermore, "A strict authority figure, such as an elderly experimenter, will usually produce a much smaller corona than the informal, friendly research assistant who replaces him."[17]

In *The Probability of the Impossible,* Moss described a study in which two people placed their fingers simultaneously on a piece of film. The resulting photograph revealed both fingerprints clearly. "However," she wrote, "if we ask them to look into each other's eyes until they feel a strong connection, and we photograph their fingerpads during that eye contact, typically we find that either one or the other of the pair has 'blanked out.' His fingerpad no longer takes a picture."[18]

Moss reached no firm conclusions from observation of this experimental phenomenon. She stated, however, that the explanation may lie in "nonverbal transactions between people, which today we describe as empathic or nonempathic feeling states."[19]

Moss has already developed consistent auric patterns that correlate fingertip coronas with emotional states. Healthy subjects exhibit a corona delineated in bluish-white with a deep-blue band—from one-sixteenth to more than one-quarter of an inch wide—just beyond the boundary of the fingertip. She found, too, that states of relaxation also lend themselves to a blue-white corona. However, in states of arousal, tension, anxiety, or emotional excitement, a red blotch

consistently appears superimposed on the fingerprint and may dissolve the coronal boundary somewhat.

Experiments with intimate couples at the Heuristic Institute showed a dramatic range of coronal responses. The fingertips of both man and woman were photographed simultaneously as each member of the pair bond was instructed to think either unpleasant or loving thoughts toward one another or engage in a kiss.

During the unpleasant thought phase, the coronal patterns did not merge. When the subjects entered the pleasant and loving thought phase or kissed, the auras seemed to blend and converge in a state of mutual attraction. The clear fingertip boundaries consistently dissolved until it was difficult to distinguish one fingerprint from another. (See Plate 15.)

Similar merging auras were produced when members of a nuclear family had their fingertips photographed simultaneously.[20] Like the Moss experiments, the Heuristic Institute studies show how emotional relationships affect the energy systems of research subjects. Systemic changes manifest themselves consistently as people relate to one another.

While commenting on psychic impressions of auras during personal interactions, Dr. Edward H. Russell, director of a parapsychology research group, noted: "Sometimes a bright spark exactly between and above two persons precedes intimate rapport based on a shared idea. I have observed people who appear to be contained in a common 'cloud of affection,' which I see as a mist or haze enveloping and flowing around and between them."[21]

Russell's description of auras applies to the technological auras produced by interpersonal Kirlian photographs. Human communication seems to be a multilevel experience, reaching far beyond the common boundaries we ascribe to it. Kirlian research into interpersonal dynamics extends our conception of the human relationship. An eloquent—yet unseen and silent—electromagnetic chorus accompanies us through our changing patterns of relationships.

Obviously, Kirlian photography may hold great promise for people interested in a better understanding of their relationships. Interpersonal Kirlian photographs may serve as graphic "maps" of the subtle, invisible interactions between people.

However, one of the problems that exist in decoding these Kirlian maps is the large range of information in the human energy field. It is something like decoding an alphabet with an infinite number of letters. Therefore, additional information about our energy fields may be needed to use Kirlian photographs effectively as maps of interpersonal interactions.

Kurt Lewin, a physicist and psychologist, devised a "field theory" that may aid in decoding these Kirlian maps.[22] Lewin's field theory is based on a set of social-scientific concepts that represent people as complex energy systems containing permeable boundaries. Models and diagrams are used to display graphically the interactions of individual "life spaces," psychic and physical "boundaries," and various "environments."

Field theory diagrams represent the total life space of an individual as consisting of the actual

person and his or her "psychological environment." Because there is a two-way communication between these aspects of the person, internal thoughts and feelings are externally revealed.

The entire life space is contained within an outer "physical environment." Occurrences that affect the outer environment produce changes in the individual's psychological environment. These inner and outer environments are further separated by boundaries.

Lewin notes that when these boundaries become rigid, little or no information is exchanged. However, when individuals feel psychologically secure, their interpsychic boundaries become fluid and permeable to outside influences.

Lewin's field diagrams, when superimposed over Kirlian photographs, may offer the additional information needed to understand nonverbal communication better, for the Lewinian concepts of life space, boundaries, and environments physically correspond with the colorful fields and emanation patterns captured with the Kirlian process.

Interpersonal Kirlian photographs of the fingertips of intimate couples represent the unseen interaction of individual life spaces. The Kirlian photograph illustrating the couple thinking unpleasant thoughts about one another displays sharp, separate, well-defined boundaries between their fingertips. The rigid quality of each life-space boundary reflects a closed position toward outside contact or communication.

In striking contrast, the picture of the same couple instructed to think loving thoughts appears

Lewin field diagram superimposed on Kirlian interpersonal study of man and woman thinking pleasant and loving thoughts toward one another

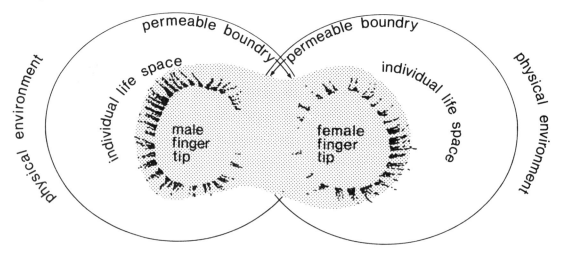

permeable and fluid, representing open interpersonal boundaries. The life spaces, or psychic boundaries, seem to blend and converge in mutual attraction toward one another.

This effect illustrates a psychological oneness that directly enhances the couple's ability to communicate more clearly. As the couple kiss, any distinction between their life-space boundaries appears to be totally lost. A beautiful and colorful bridge connects the once separate life spaces and personal environments. Spectacularly, the two intimate individuals appear to construct a single image during the act of kissing. (See Plate 15.)

The relationship between Kirlian photography and the Lewin field diagrams explores one aspect of nonverbal communication through an objective process. Lewin field theory, when graphically applied to Kirlian photography, offers an exciting new insight into decoding the infinite energy fields that surround our human relationships.

The promise of Kirlian photography consists of offering a mirror that reflects the infinite dimensions of the human being. As a medical diagnostic tool, the Kirlian process could detect changes in the health of an organism long before such changes appeared externally in the physical body. Like the X ray, Kirlian photography could detect disease. As a dynamic research tool, Kirlian photography could aid the physician by visually displaying the natural healing process. Beyond the medical dimension, the Kirlian process reveals the unseen nonverbal communication patterns that parallel the conscious thoughts, feelings, and actions we direct toward one another. Kirlian photography could thus serve as a valuable tool for assessing individual development and mental health.

Perhaps the most exciting promise of Kirlian photography, though, is in exploring our hidden psychic or spiritual dimensions. The Kirlian process offers a brief glimpse at an uncharted universe. The Kirlian aura, a modern, twentieth-century discovery, provokes new questions about our most basic beliefs and our limited knowledge of the boundaries of conventional reality.

And, presumably, we in the West believe our senses only insofar as their impressions are verified by the machines we create![23]

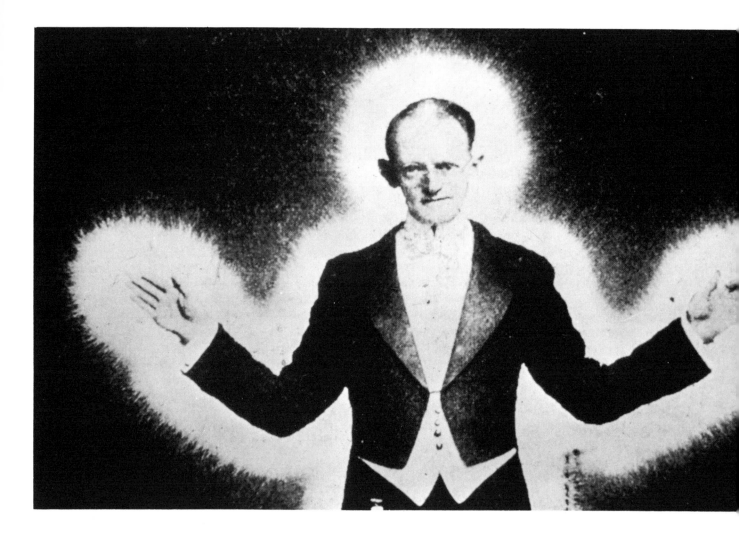

5

Colors and Kirlian Photography: Allowing Yourself to Wonder

Light itself is rarely seen. Its presence is made known by the appearance of surfaces upon which it shines.

—F. Birren

UNDERSTANDING THE MANY PERSPECTIVES OF COLOR

As we look at Kirlian photographs, we notice delicate beams of light radiating, all shining and twinkling, from every living object. Blue, red, and yellow seem graphically to map a life process normally invisible to the naked eye. Streamers of glowing color seem to blend into concentric patterns of radiant splendor. Yet what do these colors and patterns mean? Do Kirlian photographs reveal the subtle energy fields surrounding our bodies?

Because of the complexity of the visual perception of light and the photographic film medium used to capture this energy, these questions have no simple answers. To establish a clear understanding of the meaning of color in Kirlian photographs, pattern and texture must also be considered.

Since the recent introduction of Kirlian photography into the United States, several thousand pictures have been taken. Most of them contain blue-white flares and red clouds or blotches. These are the two primary color-shape combinations of Kirlian photographs.

The blue-white flares are sometimes found in the form of clusters, star points, or fiberlike tentacles. The specific patterns are partially dependent on the subject matter being photographed.

For photographic convenience, fingertips and plants are the subjects most frequently used, and those on which our color observations are based. In addition to the blue-white flares, some plant leaves and fingertips emanate red, or red-yellow, cloudlike patterns. These red, cloudlike

patterns or blotches have been interpreted by researchers as being significant of everything from drunkenness (a rosy glow), to heavy cigarette smoking (a semi-kidney-shaped blotch—see Plate 11), to the energy of interpersonal relationships (red clouds or mists—see Plate 15).

The different textures of the subject matter are reflected in the degree of detail captured with the Kirlian process. Different species of plants, like different people, seem to have their own Kirlian energy signatures (see Plate 3). Kirlian photographs beautifully reveal the incredible textures of each plant leaf—veins, external surface, and edges—and visibility of the intricate swirls of fingertips illustrates the tremendous detail that is attained through Kirlian photography.

Yet to assign specific meaning to these color patterns, several perspectives must be considered. The perspective of the physicist, the physician, and the psychologist all cast different meanings on color in Kirlian photographs.

To determine the meaning of color for himself, the physicist generally looks at the methods through which colors are produced. He views color as a type of electromagnetic energy. The spectrum of light is seen as a continuous band of color ranging from red through orange, yellow, green, blue, and violet. Colors are physically produced by radiation, refraction (that is, the bending of light rays as they pass through a prism), or fluorescence. Physicists emphasize that light waves are not in themselves color, and that color does not arise externally, but only in the human eye and brain. The perceptions of the physicist are based on proved facts that can be objectively analyzed with scientific instruments.

Recently, several American physicists have been studying Kirlian photography. Perhaps the most critical of those scientists has been William Tiller, who believes that colors are *primarily* a function of mechanical processes such as the spacing between the photographic film and the charge generated by the Kirlian apparatus. Tiller also explains the presence of these colors by describing how the three layers of film emulsion are exposed by the Kirlian generator. Additionally, he believes that the surface pressure of the Kirlian subject matter directly affects the colors we see.[1]

Tiller suggests that the Kirlian aura phenomenon can be explained appropriately within conventional concepts of physics. Although many researchers would agree with Tiller, especially with his recommendation that more adequate control over the variables is important, they would not accept his evaluation that the information available from Kirlian photography is without value.[2] After all, it has taken Russian scientists over thirty-five years to study the phenomena of Kirlian photography extensively. These dedicated researchers are still exploring many unanswered questions about the meaning of these auriclike colors and patterns.

Some American scientists, although novices in this very young field, claim to have found some answers that their Russian colleagues are diligently seeking. Physicist Richard Miller believes the Kirlian aura to be a gas. He describes the luminescent colors as being emanated

Plate 9.

Dramatic fingertip showing extensive coronal pattern.

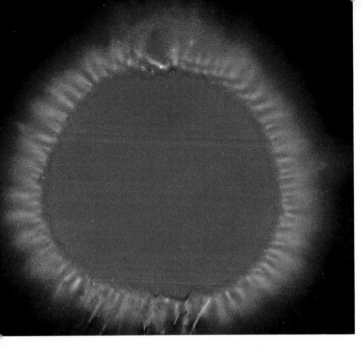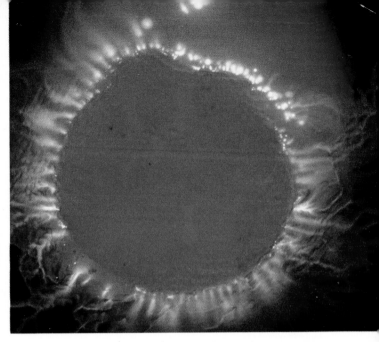

Plate 11.

(above left) *Nonsmoker's fingertip;* (above right) *Smoker's fingertip;*
(below left) *Undamaged fingertip;* (below right) *Fingertip after being
stuck by a needle*

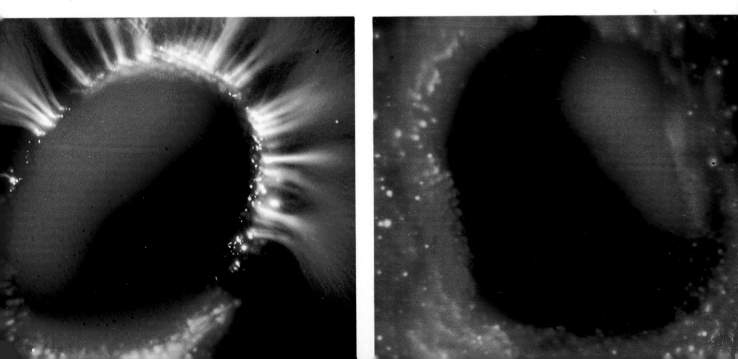

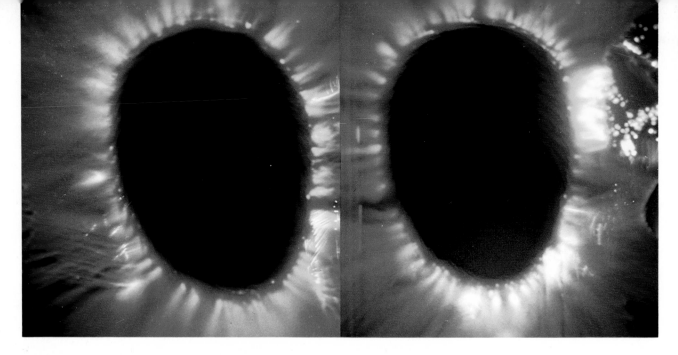

Plate 12.

(above left) *Fingertip of psychic healer, relaxed state;* (above right) *Fingertip of healer, thinking of healing;* (below left) *Fingertip of the late Reverend Plume, California healer, before a healing;* (below right) *Fingertip of the late Reverend Plume, after a healing*

Plate 13.

(opposite) *Kitten's paw*

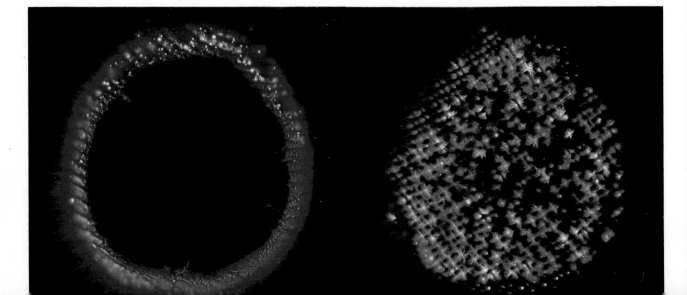

and analytical abilities. We must, instead, balance these intellectual talents with intuitive sensing, remaining open to the emotionally obvious and elusively subtle effects color has on our deeper levels of knowing and understanding.

To be able to see the many rainbows of life revealed by the Kirlian process will extend our limited vision of the universal connections of all living things.

SYMBOLIC MEANING OF COLOR

The body of man is red, his mind is yellow, and his spirit is blue. [4]

Color is a universal form of symbolism. Our color symbols are centuries old, transmitted to us through religion, tradition, and superstition.

For many early cultures, color had a deep meaning. The Tibetans, the Chinese, and the American Indians thought of directions in terms of color. For some American Indian tribes, north was represented by yellow, south by blue, east by white, and west by red. The ancient Hindus used color not only as a powerful vehicle in transcending different states of consciousness but also to represent the seven chakras (energy centers in the body) and certain forms of life energy.

Even today, occultists in many parts of the world believe that color is radiated by the human aura, or astral light, a vibrant field of energy surrounding all bodies. Specific colors in the human aura are thought to reveal a person's cultural development, spiritual perfection, and physical health.

The symbolic meaning of color is, however, strongly tied to the particular viewpoint or perception of the observer. For, quite often, subjective reactions will differ as a person associates color with the external environment or with himself or herself. For instance, a person may associate blue or green with peacefulness in one setting and find them terrifying in another.

The accompanying chart presents the major colors and their common associations.

A Wavelength of light as seen as a continuous band of Color

	RED
	ORANGE
	YELLOW
	GREEN

The Spiritual, Emotional, Mental, and Physical Associations of Color

SPIRITUAL	EMOTIONAL	MENTAL	PHYSICAL	
Beginning	Sensuality Passion Anger	Aggressiveness	Birth Primal matter Physical Universe Energy, Fire Earth	RED
Warmth	Excitement	Together in the Expression of Body and Mind Mental Radiance	Earth's Crust	ORANG
High Minded	Warmth	Thought Wisdom Intellect Mental Quickness	Sun Stimulant Nervous System	YELLO
Harmony with Mind on Earth	Tranquility	Balance of Mind and Spirit	Abundance Fruitfulness Spring	G

	VIOLET
	INDIGO
	BLUE
	GREEN

	PHYSICAL	MENTAL	EMOTIONAL	SPIRITUAL
VIOLET	Death Rebirth Passiveness	Mental Clarity Creativity	Antidote to Fear at Peace	Intuition Vision Dignity Knowing
INDIGO	Infinite depth Midnight Sky	Mental Receptivity and Regeneration	Emotional Bittersweetness Antidote to Frustration	Spiritual Insight Intuition
BLUE	Sea Sky Peace	Mental Ease	Contemplation Serenity	Spirit, Will, Truth, Divinity
GREEN	Abundance Fruitfulness Spring	Balance of Mind and Spirit	Tranquility	Harmony with Mind on Earth

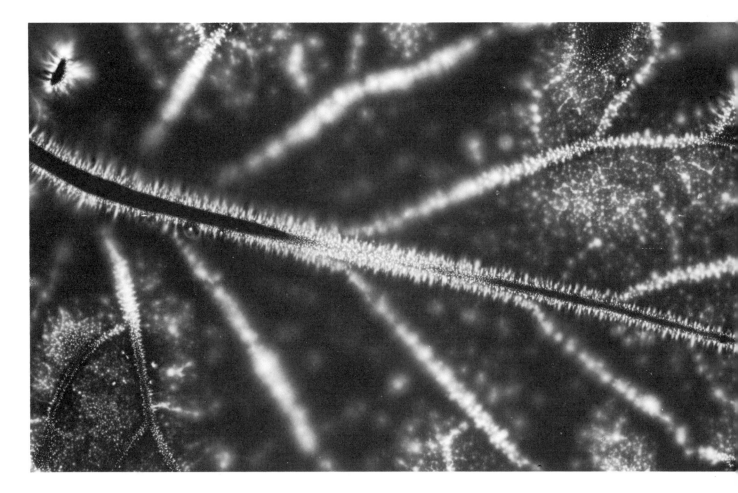

Technical Considerations

When science begins the study of nonphysical phenomena, it
will make more progress in one decade than in all the previous
centuries of its existence.

—Nikola Tesla

HOW TO TAKE KIRLIAN PHOTOGRAPHS

The film used to capture Kirlian images must be protected from light during the entire
exposure process. We recommend inserting the film with the entire Kirlian device into a large
36×49-inch light-tight photographic changing bag. Another solution to the light-exposure
problem is merely to operate in total darkness. However, some photographic papers and films
may be used under certain light conditions, making the use of these types of medium easier.

Having chosen your film, place it directly onto the electrode assembly *with the emul-
sion or "dull" side up* and facing away from the metal plate. If you use roll film, we rec-
ommend that you construct an attachment to hold the film cassette and apparatus to ad-
vance the film forward one frame after each exposure. You can also advance the film
manually, holding the cassette in one hand and pulling out the unexposed film, which
should lie across the electrode. Always remember to contact the electrode only with the
film and the object to be photographed. Any other contact to the electrode will cause an
additional interaction with the electromagnetic field and subsequent undesired exposure of
the film. If you use large sheet film, simply place the film on the electrode, with the
"notch" in the lower right-hand corner.

Once the film is properly positioned over the electrode, place the subject in direct contact
with the film. When you are photographing an object not connected to the earth, such as a
leaf plucked from a plant, a ring, or a coin, the object must be attached to the ground outlet
from the Kirlian device. This may be done by clipping the ground wire to the object or by

contacting the object with the ground wire. Be careful to keep the ground connection away from the film and electrode to avoid unwanted discharge from the wire. When photographing a textured object like a leaf, you will get maximum results by placing a piece of Plexiglas or glass on top of the leaf. This method serves to keep the object flat and ensures even surface contact with the film.

When you are photographing a human being, there is no need for any ground wire. Put the portion of the body to be photographed in direct contact with the film and activate the exposure time. You may wish to clean both the subject and the electrode first to prevent any foreign matter from scratching or contaminating the film emulsion.

Do not operate the Kirlian apparatus on any person who has a history of heart trouble or who has an implanted biomedical device such as a pacemaker. The emission of minimal amounts of X rays prohibits photographing the heart and genital regions.

Taking Kirlian Photographs Simplified

1. In total darkness, the object is placed directly on the unexposed film, emulsion side up.
2. An electrical field in excess of 12,000 volts is created by the Kirlian apparatus at the film-electrode assembly, for an exposure time of a few seconds.
3. The film is developed by standard processing techniques.

Record Keeping

To interpret the photographic results accurately, you must keep records concerning the various conditions of each subject. These may include the exposure times, specific settings of the pulse repetition rate, the particular arrangement of the subject on the film, and some identification system for each subject. When using sheet film, you might scratch a number in one corner of the negative. After the film has been developed, the numbered photos can be matched with the numbers in a notebook for an accurate description of the subjects' conditions. When using slide film developed commercially, request that the entire roll *not be cut or mounted.* You will need the uncut roll to determine which photographs correspond to which conditions as recorded in a notebook.

FILM AS A RECORDING MEDIUM

The primary means of recording an image created in the electromagnetic field of a Kirlian device is a photographic emulsion. This emulsion must be placed between the subject and the

electrode (see illustration, page 65). There is such a wide range of photographic emulsions available commercially that it would not be practical to list them all. Our experience has shown that virtually any material coated with an emulsion sensitive to the various frequencies of the electromagnetic spectrum will serve as a good image recorder (see Plate 1). There are, however, advantages in using certain types of film.

From a financial standpoint, the use of black-and-white films or papers seems to be the most practical. These films lend themselves to easy home processing and inexpensive printing. Either negative or positive film as well as enlarging paper can be effective for recording the Kirlian image. However, it is important to remember that most enlarging papers record a negative image, just like negative films. The picture captured on the photographic paper will reveal a dark pattern from a positive print. An advantage in using enlarging paper or certain black-and-white films is their insensitivity to certain wavelengths of light, which permits the use of a safety light to help illuminate the photographic area. The major disadvantage in all black-and-white recording media is that the myriad colors that can be seen using color film will register only as various shades of gray. It is most desirable to use color film to observe how the object emission patterns change under varied conditions.

Both color negatives and positive-type film are suitable for studying the color changes in an object. With negative color film you get a print that can easily be studied or displayed for others to observe. Positive or color-slide film is more difficult to display because it requires a rear light source such as a slide projector for examination. However, commercially developed, positive film is less costly, especially when using the 35-millimeter size. Standard 35-millimeter or 120 size can easily be mounted into frames for use with a slide projector. It's important to experiment with both kinds of film to determine your own preference. Since the chemistry and arrangement of the emulsions of color film may differ with each manufacturer, it is interesting to take pictures of the same object on different brands of film, keeping all other variables constant. You may observe some unexpected but very pleasing color shifts corresponding to the brand of film used. Consistently good results have been achieved with specific types of film with an ASA (light sensitivity) of at least 100.

Polaroid film yields unique images but requires a special technique for successful photographs. This technique involves pulling out an entire negative from the film pack, which must be done in total darkness. The Polaroid film pack contains a negative and paper on which the negative is printed. These must be separated so that only the film portion is exposed on the electrode. Once exposed, the two portions must be folded together again and pulled through the rollers in the back of the Polaroid camera. These rollers free the developing chemicals and spread them evenly over the film and paper surface. If you do not have a Polaroid camera for film developing, a suitable printers' roller will work. Finally, wait the appropriate amount of time and your print will be developed.

There are a few considerations in determining the size of the film you use. Roll or bulk film, 35-millimeter or 120 size, is very useful in photographing such small objects as fingertips, coins, small animals, or parts of an object. Sheet film is needed for larger objects and may also be used for multiple exposures of smaller objects. It is most important to remember to keep color film of this size sealed, refrigerated, and away from all external light.

In addition to film, there are a few other methods of capturing the Kirlian image. If you utilize a transparent conducting surface (rather than metal) as the electrode, you can observe the dynamic discharge from the object. With a standard SLR (Single Lens Reflex) camera, you can take photographs of the discharge through the transparent electrode. A television tube may also be specially adapted into an electrode to display the image on the television screen. This process offers large magnification possibilities for studying very small objects and even microscopic particles.[1] A detailed description of this adaptation is available in the literature from the Soviet Union.[2] There are also other devices developed by electronics research laboratories that analyze electromagnetic spectrum emissions, like photomultiplier tubes and oscilloscopes. These instruments are very expensive but are perhaps the most reliable means for the scientific exploration and explanation of Kirlian photographs.

Two types of Kirlian device

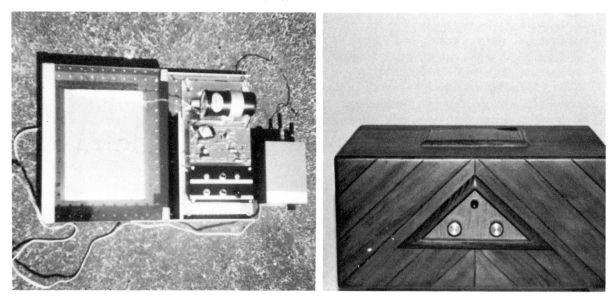

BUILDING A KIRLIAN APPARATUS

Parts

1 capacitor (electrolytic)—500 μfd. 12VDC
1 capacitor (electrolytic)—2 μfd. 500VDC
1 capacitor (tubular)—5 μfd. 12VDC
1 capacitor (tubular ceramic)—.025 μfd. 600VDC
1 capacitor (ceramic disk)—0.1 μfd. 12VDC
1 capacitor (ceramic disk)—1.0 μfd 12VDC
1 silicon controlled rectifier s/1/8″ screw and nut for RCA—RCA 2N4101 or Motorola
 2N4444
2 integrated circuits—NE555 (Signetics)
1 resistor—270 ohm, 1/2 W
2 resistors—68 kohm, 2 W
5 silicon rectifiers—any value
3 diodes—1 kv, lamp
1 potentiometer—1 megohm
1 potentiometer—50 kohm
2 dials—for potentiometers
1 switch—DPDT, 125VAC
1 switch—SPST, 125VAC
1 switch—rotary (2-pole, 5-position)
1 transformer—flyback (STANCOR No. HO–624C or exact replacement)
1 power cord—AC line type
1 power cord grommet
1 power transformer—Primary—115VAC, 60 cps; Secondary—500VAC, Center Tapped
 at 40 M.A.; and 6.3VAC @ 2 amps

IMPORTANT VARIABLES

When taking Kirlian photographs, you must consider a multitude of variables. Their relative importance to the photographic results is one of the hottest controversies involved in Kirlian research. The International Kirlian Research Association (IKRA) is currently attempting to evaluate and order the importance of these variables,[3] but only continued and con-

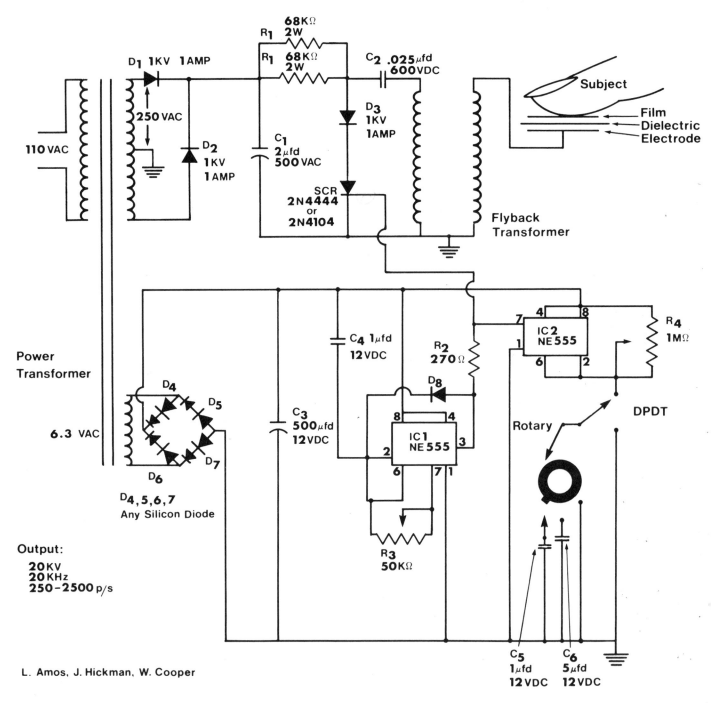

Schematic for Kirlian device

centrated research will determine their future significance.

In 1975, Yoshaiki Omura, Chairman of the International Standards Committee of the IKRA, introduced the following guidelines for variables to consider when monitoring psychological or physiological states of a subject.

1. Frequency of the high voltage source (major frequency components, including superimposed DC level or high frequency components) used for the experiment:
 a. Frequency components measured from high voltage power source.
 b. Frequency components measured at the actual experimental set-up.
2. Oscilloscopic photograph showing waveform of the high frequency voltage source used for the experiment with description of sweep velocity and vertical sensitivity.
3. Approximate range of output impedance of the high voltage, high frequency source used for the experiment.
4. Approximate maximum voltage or voltage ranges of the high voltage source, as well as wave form, polarities, pulse duration, rise and fall time and repetition rate of the high voltage pulses.
5. Minimum and maximum distance between the high voltage electrode plate and the subject to be photographed.
6. Names and characteristics of the dielectric materials (insulators) between the high voltage electrode plate and the subject and their size, thickness and geometrical arrangement.
7. Parameters of high voltage electrode plate or plates (including its shape, size, thickness and kind of metal and its surface condition).
8. Name and characteristics of the film used for photographing (including arrangement of each color sensitive emulsion layer).
9. Distance between the back of the film and the high voltage electrode plate, and the distance from various surfaces of the specimen and the front emulsion of the film.
10. Exposure time for the film and subject.
11. Grounding conditions and approximate current passing through the subject, particularly with human subjects, or degree of insulation of the subject (including the material of the socks and shoes as well as any insulation material on which the subject is standing and their electrical conductivities) as well as body weight, height, and other pertinent measurements. It is desirable to keep such a current through body (particularly through the heart) at a minimum.
12. Range of surface temperatures of the subject to be photographed (particularly with human subjects).
13. Electrical conductivity (DC resistance or electrical impedance) of the surface areas of

the subject to be photographed and the method used for measurement.

14. Whether or not the surface of the subject has been washed and cleaned before photographing (including how it was washed and dried and how long before the experiment took place.)

15. Environmental conditions including atmospheric pressure, room temperature, humidity, and degree of air pollution.

16. Pressure (approximate) exerted on the subject and the area of contact of subject with the surface of the film used.

17. Vital signs before and after Kirlian photography.

18. Safety precautions for the exposure time for high voltage discharge, electric shock (particularly the possibility of inducing ventricular fibrillation through the heart), burning of skin, and possible side effects from ozone gas, ultraviolet, and the remote possibility of x-ray generation, particularly when the voltage is very high and used for a prolonged time.

19. Experimental set-up shown in photographs or schematic diagram.

20. *Current-voltage curves recorded by oscilloscope while high voltage photography is being taken.

21. *Blood chemistry including electrolyte concentrations of different ions in the blood and C.B.C.

22. *Factors influencing circulatory conditions of various parts of the body, which in turn influence surface temperatures and electrical conductivity. Mental state is one of these factors.

23. *Microcirculatory states of the area of the body to be photographed.

24. *Other pertinent information about subjects or experimental set-up or procedure.

*Denotes factors which are desirable but not essential.

Notes

CHAPTER 1—THE HUMAN AURA

1. Carlos Castaneda, *A Separate Reality* (New York: Simon & Schuster, 1971), p. 131.
2. Swami Sivananda, *The Science of Pranayama* (Rishikesh, India: Yoga Vendenta Forest Academy Press, 1962), p. 305.
3. *Some Unrecognized Factors in Medicine* (London: Theosophical Research Centre and Publishing House, 1939).
4. *Ibid.*
5. Irving Oyle, *The Healing Mind* (Millbrae, Calif.: Celestial Arts, 1975), p. 42.
6. F. L. Yu, *T'ai Ch'i Nude* (San Francisco: And/Or Press, 1975), p. 12.
7. Max F. Long, *The Secret Science Behind Miracles* (Los Angeles: Huna Research Publications, 1948), p. 82.
8. *Ibid.,* p. 138.
9. Edward W. Mann, *Orgone, Reich and Eros* (New York: Simon & Schuster, 1973), p. 143.

CHAPTER 2—THE FORGOTTEN HISTORY OF LIFE ENERGY

1. Aubrey Westlake, "Further Wanderings in the Radiesthetic Field," *Journal of the British Society of Dowsers,* December 1951.
2. Brian Inglis, *A History of Medicine* (Cleveland, Ohio: World Publishing Company, 1965).
3. Westlake, "Further Wanderings," p. 5.
4. W. Edward Mann, *Orgone, Reich and Eros* (New York: Simon & Schuster, 1973), p. 86.
5. Westlake, "Further Wanderings," p. 69.
6. *Ibid.,* p. 114.
7. John C. Colquhoun, *Report on Experiment on Animal Magnetism to the Edinburgh Society* (Edinburgh: Robert Cadell, 1833).
8. Margaret L. Goldsmith, *Franz Anton Mesmer* (Garden City, N.Y.: Doubleday, 1934).
9. Harold S. Burr, *The Fields of Life* (New York: Ballantine, 1973).
10. Mann, *Orgone, Reich and Eros,* p. 96.
11. John Joseph O'Neill, *Prodigal Genius; The Life of Nikola Tesla* (New York: I. Washburn, 1944).
12. Mann, *Orgone, Reich and Eros,* p. 145.
13. René Sudre, *Parapsychology* (New York: Citadel Press, 1960).
14. Emile Boirac, *Our Hidden Forces* (New York: Stokes, 1917).
15. Zdenek Rejdak and F. Krbal, "From Mesmer to the Fifth Physical Interaction and Biological Plasma," *Journal of Paraphysics,* May 1971, p. 11.
16. Harold S. Burr, "Electrometrics of Atypical Growth," *Yale Journal of Biology and Medicine,* Vol. 25 (1952–53).

17. L. J. Ravitz, "Bioelectric Correlates of Emotional States," *Connecticut State Medical Journal,* Vol. 16 (1952), p. 499.

18. Wilhelm Reich, *Character Analysis* (New York: Farrar, Straus and Giroux, 1949).

19. _____, *The Cancer Biopathy* (New York: Orgone Institute Press, 1948).

20. T. Colson, "Living Tissue Rays," *Electronic Medical Digest,* Summer 1945.

CHAPTER 3—WHAT IS KIRLIAN PHOTOGRAPHY?

1. S. Ostrander and L. Schroeder, *Psychic Discoveries Behind the Iron Curtain* (Englewood Cliffs, N.J.: Prentice-Hall, 1970).

2. S. D. Kirlian and V. K. Kirlian, *"Photography and Visual Observations by Means of High-Frequency Currents," Journal of Scientific and Applied Photography,* Vol. 6 (1961), pp. 397–403.

3. S. Krippner and D. Rubin, *The Kirlian Aura* (Garden City, N.Y.: Anchor, 1974).

4. Kirlian, "Photography and Visual Observations," p. 72.

5. V. M. Inyushin, *The Biological Essence of the Kirlian Effect* (Alma-Ata, Kazakh, U.S.S.R: Kazakh State University, 1968).

6. V. M. Inyushin, "Biological Plasma of Human Organism with Animals" (Prague: Svoboda, 1970). (Privately translated from the Russian.)

7. "Kirlian Photography," *Medical World News,* Vol. 14, No. 39 (Oct. 26, 1973).

8. *Ibid.*

9. A. Zucconi, paper presented to the First European Conference on Kirlian Photography, sponsored by the University of Naples (Italy, January 1974).

10. Kendall Johnson, *The Living Aura* (New York: Hawthorn, 1975), p. 172.

11. *Ibid.*

12. Hans Jenny, *Cymatics: Structure and Dynamics of Waves and Vibrations,* Vol. 1 (New York: Schocken, 1975).

13. Lawrence Blair, *Rhythms of Vision: The Changing Patterns of Belief* (New York: Schocken, 1976), p. 68.

14. Fritjof Capra, *The Tao of Physics* (Berkeley: Shambhala, 1975).

15. *Ibid.*

16. Alan Watts, *The Joyous Cosmology* (New York: Pantheon, 1961).

CHAPTER 4—THE PROMISE OF KIRLIAN PHOTOGRAPHY

1. For further information concerning Olga Worrall, see Thelma Moss, *The Probability of the Impossible* (Los Angeles: J. P. Tarcher, 1974).

2. Statement by Dr. Luis Zanin, personal interview, August 1975, Bogotá, Colombia.

3. Occasionally cited in medical literature is a phenomenon experienced by people who, having had limbs removed surgically, later report feelings or tingling sensations in the body portion previously amputated. Amputees who continue reporting these sensations to their physicians find their scientifically unknown cause becomes labeled "psychosomatic"—that is, medically believed to be created solely by the mind.

4. John C. Lilly, *Center of the Cyclone* (New York: Julian Press, 1972).

5. Ostrander and Schroeder, *Psychic Discoveries,* p. 216.

6. *The Medical Science Gazette,* "The Kirlian Effect and Medical Science" (official organ of the Ministry for Health Preservation of the U.S.S.R., Ministry of Medical Technology and Central Committee of the Organizations of Medical Specialists), No. 64 (3575), (August 11, 1976). Translated by L. Konikiewicz and D. Dean.

7. H. S. Dakin, *High-Voltage Photography* (San Francisco: H. S. Dakin, 1974), p. 14.

8. Brain-wave frequencies measured before and after smoking were normally within the beta range (13 cycles per second [CPS] and above). However, immediately upon smoking, brain-wave frequencies slowed down to the high alpha range (8–12 CPS).

9. W. Edward Mann, *Orgone, Reich and Eros* (New York: Simon & Schuster, 1973), pp. 160–169.

10. Louis Moss, *Acupuncture and You* (New York: Citadel, 1966).

11. Irving Oyle, *The Healing Mind* (Millbrae, Calif.: Celestial Arts, 1975).

12. Stanley Krippner and Albert Villoldo, *The Realms of Healing* (Millbrae, Calif.: Celestial Arts, 1976).

13. S. Krippner and D. Rubin, *The Kirlian Aura* (Garden City, N.Y.: Anchor, 1974).

14. "Kirlian Photography," *Medical World News,* Vol. 14, No. 39 (Oct. 26, 1973).

15. *Ibid.*

16. *Ibid.*

17. Krippner and Rubin, *Kirlian Aura.*

18. Thelma Moss, *The Probability of the Impossible* (Los Angeles: J. P. Tarcher, 1974).

19. *Ibid.*

20. See interpersonal studies photos in Earle Lane, *Electrophotography* (San Francisco: And/Or, 1975), p. 47.

21. Edward H. Russell, "Parapsychic Luminosities," *Quadrant,* Vol. 8, No. 2 (Winter 1975), p. 61.

22. Krippner and Rubin, *Kirlian Aura.*

23. *Ibid.*

CHAPTER 5—COLOR AND KIRLIAN PHOTOGRAPHY:
ALLOWING YOURSELF TO WONDER

1. Carolyn Dobervich, "Kirlian Photography Revealed," *Psychic* (November/December 1974), pp. 34–39.

2. D. Faust, H. J. Kyler, and J. O. Pehek, "Image Modulation in Corona Discharge Photography," *Science,* Vol. 194, No. 4262 (Oct. 15, 1976).

3. R. A. Miller, *Bioluminescence, Kirlian Photography and Medical Diagnostics* (Seattle: R. A. Miller, 1974).

4. F. Birren, *Color Psychology and Color Therapy* (Secaucus, N.J.: University Books, 1961).

CHAPTER 6—TECHNICAL CONSIDERATIONS

1. Color Kirlian motion pictures have been developed at the Naval Post Graduate Academy, Monterey, Calif., by G. K. Poock & P. W. Sparks.

2. S. D. Kirlian and V. H. Kirlian, *In the World of Miraculous Discharges* (Moscow: Znaniye, 1964).

3. The International Kirlian Research Association is located at 411 East Seventh Street, Brooklyn, N.Y.

4. D. Faust, H. J. Kyler, and J. O. Pehek, "Image Modulation in Corona Discharge Photography," *Science,* Vol. 194, No. 4262 (Oct. 15, 1976).

Bibliography

Allen, William Gordon. *Enigma—Fantastique.* Mokelumne Hill, California: Health Research, 1966.

Anderson, Marianne S., and Louis M. Savary. *Passages: A Guide for Pilgrims of the Mind.* New York: Harper & Row, 1972.

Bagnall, Oscar. *The Origin and Properties of the Human Aura.* Secaucus, N.J. University Books, 1970.

Becker, Robert O. "Relationship of Geomagnetic Environment to Human Biology." *New York State Journal of Medicine,* Aug. 1, 1963, pp. 2215–2219.

Birren, F. *Color and Psychology and Color Therapy.* Secaucus, N.J. University Books, 1961.

Bizzi, Bruno. "Orgone Energy: Life Force and Morbid States." *Energy and Character,* Vol. 1, No. 1, Spring 1970.

Blair, Lawrence. *Rhythms of Vision: The Changing Patterns of Belief.* New York: Schocken Books, 1976.

Boirac, Émile. *Our Hidden Forces.* New York: Stokes, 1917.

Burr, H. S. *Blueprint for Immortality.* London: Neville, Spearman, 1972.

_____."Electrometrics of Atypical Growth." *Yale Journal of Biological Medicine,* Vol. 25, 1952–53.

_____. *The Fields of Life.* New York: Ballantine, 1973.

_____. *The Nature of Man and the Meaning of Existence.* Springfield, Illinois: Charles C. Thomas, 1962.

Capra, Fritjof. *The Tao of Physics.* Berkeley, Calif.: Shambhala Publications, Inc., 1975.

Castaneda, Carlos. *A Separate Reality.* New York: Simon & Schuster, 1971.

Colquhoun, John Campbell. *Report on Experiment on Animal Magnetism to the Edinburgh Society.* Edinburgh: Robert Cadell, 1833.

Colson, T. "Living Tissue Rays." *Electronic Medical Digest,* Summer 1945.

Dakin, H. S. *High-Voltage Photography.* San Francisco: H. S. Dakin, 1974.

Garrison, Omar V. *Tantra: The Yoga of Sex.* New York: Julian Press, 1964.

Gerard, R. "Differential Effects of Colored Lights on Psychophysiological Functions." *American Psychology,* Vol. 13, p. 340.

Goldsmith, Margaret L. *Franz Anton Mesmer.* Garden City, N.Y.: Doubleday, 1934.

Goldstein, K. *The Organism.* New York: American Book, 1939.

Goodavage, Joseph F. *Magic: Science of the Future.* New York: Signet Books, 1976.

Hameroff, Stuart. "Ch'i: A Neural Hologram? Microtubules, Bioholography, and Acupuncture." *American Journal of Chinese Medicine,* Vol. 2, No. 2, 1974, pp. 163–170.

Hickman, J. L. "A High-Voltage Photography Experiment with Uri Geller." *Psychoenergetic Systems,* Gordon and Breach Science Publishers, Vol. 2, 1977, pp. 119–130.

Huxley, Aldous. *The Doors of Perception.* New York: Harper & Row, 1954.

Inglis, Brian. *A History of Medicine.* Cleveland: World Publishing Company, 1965.

Inyushin, V. M. *The Biological Essence of the Kirlian Effect.* Alma-Ata, Kazakh, U.S.S.R.: Kazakh State University, 1968.

_____.*Biological Plasma of Human Organism with Animals.* Prague: Svoboda, 1970. (Privately translated from the Russian.)

Jenny, Hans. *Cymatics: Structure and Dynamics of Waves and Vibrations,* Vol. 1. New York: Schocken, 1975.

Johnson, Kendall. *The Living Aura.* New York: Hawthorn Books, Inc., 1975.

Russell, E. H. "Parapsychic Luminosities." *Quadrant,* Vol. 8, No. 2, Winter 1975.

Kelley, C. R. "What Is Orgone Energy?" *The Creative Process,* Vol. 2, No. 1, pp. 58–80.

Kim, B. H. "On the Kyungrak System." *Journal of the Democratic People's Republic of Korea,* No. 2, 1965.

Kirlian, S. D., and V. K. Kirlian. "Photography and Visual Observations by Means of High-Frequency Currents," *Journal of Scientific and Applied Photography,* Vol. 6, 1961, pp. 397–403.

————. *In the World of Miraculous Discharges.* Moscow: Znaniye Publishing House, 1964.

Krippner, Stanley, ed. "Psychoenergetic Systems." Gordon and Breach Science Publications, Vol. 1, 1974.

Krippner, S., and D. Rubin. *The Kirlian Aura.* Garden City, N.Y.: Anchor Books, 1974.

Krippner, S., and A. Villoldo. *The Realms of Healing.* Millbrae, Calif.: Celestial Arts, 1976.

Krivorotov, V. K., and A. E. Krivorotov. "Bioenergotherapy and Healing." *Psychoenergetic Systems,* Vol. 1, 1974, pp. 27–30.

Lane, Earle. *Electrophotography.* San Francisco: And/Or Press, 1975.

Lewin, K. *A Dynamic Theory of Personality.* New York: McGraw-Hill, 1935.

Lilly, John C. *Center of the Cyclone.* New York: Julian Press, 1972.

Long, Max Freedman. *The Secret Science Behind Miracles.* Los Angeles: Huna Research Publications, 1948.

Mann, W. Edward. *Orgone, Reich and Eros.* New York: Simon & Schuster, 1973.

The Medical Science Gazette, Official Organ of the Ministry for Health Preservation of the U.S.S.R., Ministry of Medical Technology and Central Committee of the Organizations of Medical Specialists, No. 64 (3575), 1976. "The Kirlian Effect and Medical Science." Translated by L. Konikiewicz and D. Dean.

Medical World News, Vol. 14, No. 39, Oct. 26, 1973.

Miller, R. A. *Bioluminescence, Kirlian Photography, and Medical Diagnostics.* Seattle: R. A. Miller, 1974.

Milner, Dennis, and Edward Smart. *The Loom of Creation.* New York: Harper & Row, 1976.

Mishlove, Jeffrey. *The Roots of Consciousness.* New York: Random House/Bookworks, 1975.

Moss, Louis. *Acupuncture and You.* New York: Citadel Press, 1966.

Moss, Thelma. *The Probability of the Impossible.* Los Angeles: J. P. Tarcher, 1974.

O'Neill, John Joseph. *Prodigal Genius; The Life of Nikola Tesla.* New York: I. Washburn, 1944.

Ostrander, S., and L. Schroeder. *Psychic Discoveries behind the Iron Curtain.* Englewood Cliffs, N.J.: Prentice-Hall, 1970.

Ousley, S. G. J. *The Science of the Aura.* London: L. N. Fowler and Co., Ltd., 1949.

Oyle, Irving. *The Healing Mind.* Millbrae, Calif.: Celestial Arts, 1975.

Panchadosi, Swami. *The Human Aura.* Chicago: Advanced Thought Publishers, 1916.

Pehek, John O., Harr J. Kyler, and David L. Faust. "Image Modulation in Corona Discharge Photography," *Science,* Vol. 194, No. 4262, Oct. 15, 1976.

Powell, A. E. *The Etheric Double.* Wheaton, Ill.: Theosophical Publishing House, 1969.

Prat, S., and J. Schlemmer. "Electrophotography," *Journal of the Biological Photography Association,* Vol. 7, 1939, pp. 145–148.

Pressman, A. S. *Electromagnetic Fields and Living Nature.* Moscow: Academy of Sciences, U.S.S.R., Science Publishing, 1968.

Puharich, A. *Beyond Telepathy.* New York: Simon & Schuster, 1971.

Ravitz, L. J. "Bioelectric Correlates of Emotional States," *Connecticut State Medical Journal,* Vol. 16, 1952, p. 499.

Reich, Wilhelm. *Character Analysis.* London: Vision Press, 1950.

————. *The Cancer Biopathy.* New York: Orgone Institute Press, 1948.

Rejdak, Zdenek, and F. Krbal. "From Mesmer to the Fifth Physical Interaction and Biological Plasma," *Journal of Paraphysics,* May 1971.

Russell, E. H. *Design for Destiny.* New York: Ballantine Books, 1971.

Ryan, J. "Thermography," *Australian Radiology,* Vol. 13, No. 1, February 1969.

Samuels, Mike, and Nancy Samuels. *Seeing with the Mind's Eye.* New York: Random House/Bookworks, 1975.

San Francisco Chronicle, April 19, 1974.

Sivananda, Swami. *The Science of Pranayama.* Rishikesh, India: Yoga Vendenta Forest Academy Press, 1962.

Some Unrecognized Factors in Medicine. London: Theosophical Research Centre and Publishing House, 1939.

Sudre, René. *Parapsychology.* New York: Citadel Press, 1960.

Szent-Györgyi, A. *Bioelectronics.* New York: Academic Press, 1968.

_____. *Introduction to a Submolecular Biology.* New York: Academic Press, 1960.

Tansley, David V. *Subtle Body.* London: Thames and Hudson, 1977.

Tiller, W. A. Publications c/o Department of Material Sciences, Stanford University, Palo Alto, Calif.

Watts, A. *Psychotherapy: East and West.* New York: Pantheon, 1961.

Westlake, Aubrey. "Further Wanderings in the Radiesthetic Field," *Journal of the British Society of Dowsers,* December 1951.

Yu, F. L. *T'ai Ch'i Nude.* San Francisco: And/Or Press, 1975.

Zucconi, A. Paper presented to the First European Conference on Kirlian Photography, sponsored by the University of Naples. Italy, January 1974.

Glossary

acupuncture Chinese art of preventing and curing disease through the stimulation of certain points in the subcutaneous tissue.

alchemy An ancient science and philosophy whose aims were the transmutation of base metals into gold, the discovery of cure-alls, and preparation of the elixir of longevity.

archaeus A universal essence that makes up the invisible body of all beings.

armor The total defense apparatus of the organism, consisting of the rigidities of the character and the chronic spasms of the musculature, which functions essentially as a defense against the breakthrough of the emotions —primarily anxiety, rage, and sexual excitation.

aura Colorful emanations of light surrounding the human body; often seen by saints, psychics, and sensitives.

bioenergetics A system of psychotherapy rooted in Wilhelm Reich's theory of life energy and based on breathing and the release of muscular armoring.

bioluminescence Emission of visible light from living organisms such as the firefly and various fish.

bioplasma Plasma is a loosely associated ionized gas cloud that is susceptible even to weak magnetic fields. Bioplasma is the biological form of the fourth state of matter.

bleeding-leaf effect A phenomenon reported by Thelma Moss, whereby a plant leaf that has been gashed with a needle will reveal a large red blotch when photographed by means of the Kirlian process.

cold electron emission Electrons that are literally sucked off a point of metal by an extremely high voltage field.

coronal patterns A faint glow of streamers of light emanating from an object placed in a high-frequency, high-voltage field.

double-blind method Experimental research method in which the experimenters, subjects, and evaluators do not have any previous information about one another.

electrical impedance The amount of opposition to current flow in an alternating-current circuit.

electrodynamics In physics, the relationship between electric, magnetic, and mechanical phenomena.

electromagnetic spectrum The entire range of electromagnetic radiation. All scientific instruments perceive some part of this spectrum. Its frequency is measured in cycles per second (CPS).

electromagnetism Magnetism arising from a current of electricity.

electrotherapy Medical therapy utilizing electric currents.

emotional plaque Reichian term describing a disease created by various levels of human oppression (racism, nationalism, sexism, economic and social pressures) that causes blocked or repressed energy.

enomron Invisible emanations believed by Hippocrates to surround all organisms.

etheric double Metaphysical term similar in meaning to aura.

field theory of social science Theory devised by Kurt Lewin to describe graphically the complex interactions of individuals, their environments, and social systems.

high frequency Used in physics to denote an electrical field (specifically its wavelength) that consists of a large number of cycles per second.

kahuna Hawaiian shaman or medicine man.

L-fields Also called "fields of life," the electrical patterns that exist within and surround all living organisms. Discovered by Harold Saxon Burr.

liquor vitae Life fluid containing the nature, quality, character, and essence of all beings.

mana Hawaiian word referring to a life-force that could be transmitted to others.

meridians Channels through which vital life energy flows through the body.

microtubules Physical structures that serve as transporting channels for life energy, discovered by an Arizona medical research team.

muscular armoring Process whereby individuals create continuous muscle spasms or tension in various parts of the body that is often associated with psychological or emotional dysfunction.

negative ion An atom (or group of atoms or molecules) that has a negative electrical charge acquired by gaining electrons.

orgone energy Primordial cosmic energy, universally present and demonstrable visually, thermically, electroscopically, and by means of Geiger-Müller counters. In living organisms, bioenergy, life energy. Discovered by Wilhelm Reich between 1936 and 1940.

oscilloscope An instrument used to display variations in electrical quantities, which appear as waveforms on a cathode-ray tube.

peripheral vasoconstriction A narrowing of the blood vessels in the hands and feet.

phantom-leaf effect A phenomenon revealed through the Kirlian process. When a small portion of a "normal" leaf is removed and the leaf is photographed, the energetic pattern of the missing part mysteriously appears.

photomultiplier tube An electronic device in which electrons released by photoelectric emission are multiplied in successive stages by dynodes that produce secondary emission.

structural integration Properly called rolfing, after Ida Rolf. The intent is to reintegrate the body by breaking down muscular armoring.

Index

About the Authors

Mikol S. Davis, M.A., M.F.C.C., senior author of *Rainbows of Life*, is a practicing child and family counselor and director of the Communication Skills Center in Mill Valley, California. He is completing his doctorate in educational psychology and counseling and has been an instructor and lecturer in psychology and communication at numerous California colleges and universities. In 1973 he was a guest at the First International Congress of Parapsychology and Psychotronics in Prague.

Earle Lane, technical researcher, has a bachelor's degree in transpersonal psychology and a master's degree in psychotronics. He has extensive experience with microcircuit electronics and has designed, manufactured, and marketed his own biofeedback devices, electronic acupuncture equipment, and Kirlian apparatus. He has conducted many research projects in acupuncture, biofeedback, and Kirlian photography as well as developed wound-healing studies with Veterans Administration hospitals.